GOING UNDERGROUND
THE POTTERIES

ANTHONY POULTON-SMITH

AMBERLEY

First published 2023

Amberley Publishing, The Hill, Stroud
Gloucestershire GL5 4EP

www.amberley-books.com

British Library Cataloguing in Publication Data.
A catalogue record for this book is available from the British Library.

ISBN 978 1 3981 0175 3 (print)
ISBN 978 1 3981 0176 0 (ebook)

Typesetting by SJmagic DESIGN SERVICES, India.
Printed in the UK.

CONTENTS

1

BENEATH OUR FEET

The Potteries' population is approaching 450,000. This conurbation includes the city of Stoke and associated towns, as well as the land between and around. Situated in the north of the Midlands, the region provides an important link with other towns and cities of the region and the larger cities of Liverpool, Manchester and Chester. The area has a busy railway hub, watercourses and a good number of A roads and one of the country's busiest motorways. Be it on water, rail or road, travellers, at some point, find themselves below ground level as they pass through the region.

Like many conurbations, the Potteries' earlier days often lie buried beneath more recent constructions. An important town since the thirteenth century, the population grew steadily until the Industrial Revolution saw growth accelerate, although most came in the last two centuries. Very few will have seen what exists beneath more than the area's 100 square miles. Likely the most any of us will have seen is by peering into the hole opened to allow maintenance, be it telephone, cable, power lines, gas and water pipes, or sewage. Some will have travelled, on boats or on foot, through the tunnels cut by canal builders more than two centuries ago. Many more will have travelled tunnels bringing railways from the nineteenth century. Yet little can be seen on a boat or train.

Many will know the Potteries, the conurbation which is Stoke-on-Trent and the surrounding area. Growing up, living, working, playing or just visiting any of the famed six towns of Stoke, Hanbury, Burslem, Tunstall, Longton, and Fenton, familiar sights will have included the bottle kilns synonymous with the area.

A cross-section of an almost ordinary town centre street will come as a surprise. One of the most common sights for us are the drains. Metal grilles at the roadside remove water collecting in the gutters and take it – well, we will see later. Having to be open to the sky to permit water to drain makes these the most familiar to us. But we can only see a small opening and depth perception is difficult. Legislation defines the maximum and minimum depths of drainage systems as between 75 cm and 135 cm below the finished ground level. Note this is not the natural level but the finished level after construction.

These depths are not chosen arbitrarily. A minimum of 75 cm ensures protection from frost under normal conditions in the United Kingdom – although 'normal' can differ widely in terms of location and altitude. But a maximum of 135 cm also allows reasonable access for repairs and/or maintenance.

Surface water drains are initially shallow and drain away in one of three ways. It is not desirable to direct this to the sewers and so-called foul water if possible. For quite isolated

properties the surface water is likely drained to a soakaway adjacent to, or quite near, the property. Alternatively, there may be a dedicated surface water sewer, often referred to as a stormwater drain, which probably empties into a nearby watercourse. Finally, surface water can be directed into the sewer, along with the foul water, although technically a sewer is only referred to as such when it serves more than one property, otherwise it is merely a drain. It is easy to see how confusion exists when a sewer can sometimes be a drain and vice versa, and that does not take into consideration the complexity of sewerage laws.

We should also look at the different methods of how sewage moves along and where it ends up. Some remote locations will utilise a septic tank or sludge tank. However, the vast majority is taken to sewerage farms where it is treated and separated into clean water and recyclable organic products. Water heads to the river system, nature's drains, the reclaimed organic matter used for fertilisers. Unfortunately, other items also find a way into the sewerage farms. Be they washed down drains after being discarded thoughtlessly instead of using many waste bins provided, or wrongly flushed down a toilet, they are retrieved, segregated and dealt with separately. There are very good reasons why we are told not to put oil-based products down a drain or flush anything other than toilet paper and what that paper is designed to clean up.

University Hospital today where a tunnel permits travel between departments under the ground.

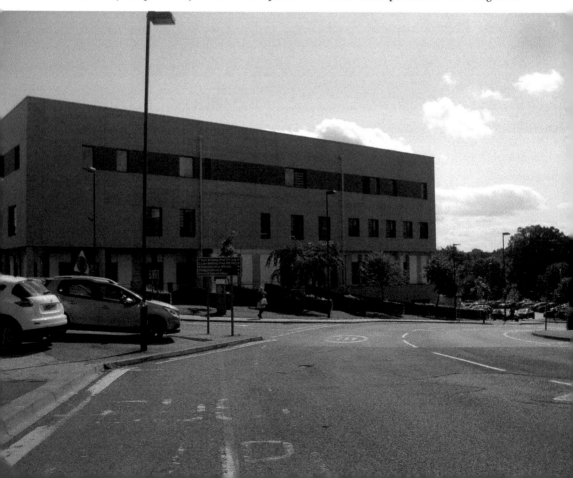

Sewage movement uses the simplest of technologies: gravity and liquid water. Next time you ascend that steep hill, glad to reach the summit when at least a little out of breath, look back and think about what is happening underground. Imagine what would happen if the load of sewage contained in that drop could be seen above street level. It would all be at the foot of the slope. If that happened underground the system would soon be blocked and so a series of steps create waterfalls and deliver its contents to the bottom of the slope in a manageable volume. Little and nothing can go wrong with this system. Hence if the road has been dug up for repair to the sewer, it is likely the problem is caused by incorrect use of the system.

Perhaps one of the most common problems in sewerage systems are those known as 'fatbergs'. These are clumps of non-biodegradable matter (i.e. that which should not be in the sewers), which form and build up to such a size they will easily block the sewer. In London 2018, a fatberg was discovered in a sewer comprised of congealed fat from kitchens, wet wipes, disposable nappies, oil and condoms. It took nine weeks to restore the sewer to a working condition. Nine weeks in which 250 metres of sewer was cleared, a little at a time, until all 130 tons of this 'toxic monster' had been removed. Such shows the dimensions of the sewers beneath our feet.

Generally, sewers are of smaller dimensions than the London home of the Whitechapel Fatberg. These can be quite shallow in some places but normally sewage pipes will be almost 2 metres below ground. This helps prevent problems caused by sub-zero temperatures – a frozen river of biodegradable sewage would soon cause appalling problems for the world above. Not least the obnoxious odours.

When school chums pointed out 'stinkpipes' or 'stenchpoles' on the way to and from school, they would add how these were to remove the smell from the sewers. Their stories were half right. They are linked to the sewers but exist more to allow the escape of methane, a potentially explosive gas which is a by-product of the sewage breaking down.

Not only water and sewage are found in underground pipes. While some houses today are all-electric, once upon a time gas was the only source of power into domestic properties. Not, as we would think, for cooking and heating – most often cooking was done on the range and heating by coal fires. As with water supplies, gas came through a main pipe to an area and then tapped to individual houses. Legislation demands a gas main be buried a minimum of 75 cm under a road or verge and 60 cm under a footpath. Service pipes to each property should have a minimum depth of 37.5 cm on private ground and 45 cm under footpaths and highways.

Anyone who has stood alongside a hole where excavations have revealed gas mains will be aware the visible pipe is well below 75 cm deep. This is also the case with water and sewers, both of which are much older than cables laid for electricity, television and the internet. Do not think this shows previous generations were willing to bury the pipes lower. Indeed, the reverse is true and the reason the pipes are deeper down is because street level is higher than ever. It is natural to build on top of earlier constructions and as archaeologists will tell you, the deeper you dig the further back in time you get.

Clearly cable television and internet services are little more than a generation old. As already noted, electricity supplies are much more recent – the six towns not having access to an electricity supply until 1910, although many stuck with gas lamps until much later.

Cables are much easier to damage than pipes and should be enclosed in a conduit for added protection. Furthermore, all cables are coded, using coloured cable, tape, warning devices, marks and any number of other marks.

Under roads and pavements, such should be a minimum of 60 cm beneath the surface, although on private property this changes to 45 cm for driveways, 15 cm beneath soil or grass, and 10 cm beneath concrete or paving. Note the recommended depth for flower beds is usually given as two spade depths as they are likely to be dug over.

With all these beneath our towns and cities, we tend to take these utilities for granted. Indeed, we hardly consider what lies there until they fail to work and then roads are dug up to correct the problem. This is when we hear how this street or that road is up again! And this only applies to where the streets are at the natural level of the natural topography. For those areas developed after years of mining or quarrying, depths are far greater.

We have still to address the subterranean passages used by canal boats, natural waterways, and railway tunnels. Then we have basements, both modern and old, used and abandoned, hidden, forgotten and even, on occasions, still utilised. And we must not forget the archaeology. While not technically accessible, which probably prevents any suggestion they are 'underground' and should be considered 'buried', they do warrant at least a brief look.

In the following pages something of the hidden world beneath the ground will be revealed. All manner of surprising discoveries unearthed: some well-known or predictable, others long buried, forgotten or previously unknown.

The Best Western Hotel occupies the former Hanley Station site ...

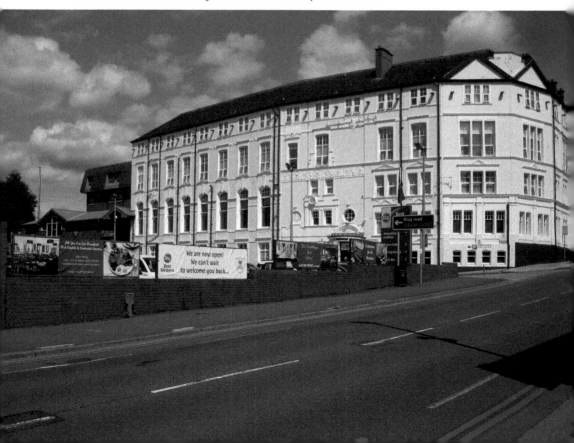

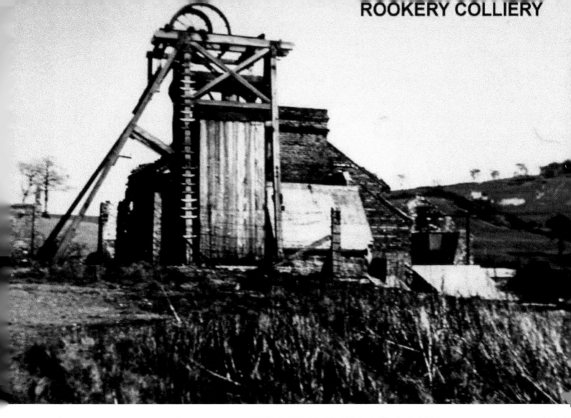

Above: ... with the car park laid over what had been the station's yard.

Right: Once these tracks at Hanley headed underground through a tunnel to Basford Hall ...

2

HARECASTLE TUNNELS

Although always referred to as Harecastle Tunnel, there have been no fewer than six tunnels with this name. Each has a different history. Two were built to link the rivers Trent and Mersey with the Caldon Canal and the Trent and Mersey Canals. Josiah Wedgwood cut the first sod for the Caldon at Middleport in 1776 following the Act of Parliament to permit the building of this new waterway.

The first of these canal tunnels, built by James Brindley, measures 2,633 metres. It has no towpath and thus boats were brought through by leggers, men who propelled

Campbell Place still has a stretch of canal hidden beneath it.

Above: Campbell Place is not named to show its importance as a waterway.

Right: Old canal at Boothen Old Road.

the boat through the tunnel by lying on their backs and walk sideways along the walls or ceiling – the curved shape makes it difficult to know where the wall ends and the ceiling starts. Walking such a distance is not only an exhausting and back-breaking three-hour trip but also proves a major bottleneck for traffic coming to and from the pottery works at Etruria. It was opened in 1777, five years after Brindley's death. In 1827 the great civil engineer Thomas Telford received a commission to build a second tunnel. Wider and parallel to the first, it included a towpath and measured 2,676 metres when opening in 1827.

At the beginning of the twentieth century the older Brindley tunnel closed when a roof collapse created a blockage, making it unusable and preventing the two operating as a dual waterway. Reports on the cause of the fall point either to subsidence, or vibration from the railway tunnel running above here. The second canal tunnel, despite also suffering problems, remains open and in use today. It is the fourth-longest navigable canal tunnel in the United Kingdom. But its great length is not what makes Harecastle's remaining tunnel famous.

While the Brindley tunnel has been blocked off to traffic by extending the quayside, it is not completely sealed off. The water between the two tunnels can mix and it is easy to see from which tunnel the flow originates, for that from the Brindley tunnel is clearly red as a result of it seeping through the iron ore deposit resulting from the subsidence. To combat

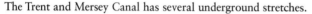

The Trent and Mersey Canal has several underground stretches.

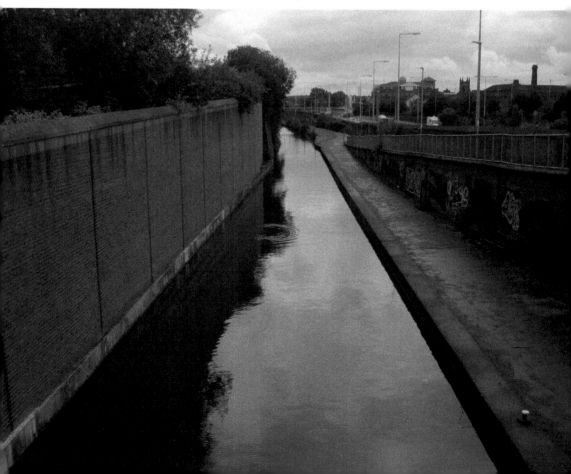

the problem, a bed of reeds has been planted to actor as a filter for the sediment and stop the blood-red waters from flowing further down the canal.

Telford's later canal tunnel continues to make the news in the twenty-first century. In May 2014, a man from Cumbria fell from the boat in the mile and a half tunnel. Emergency services closed the tunnel overnight and, with a specialist underwater team, recovered the body within hours. A headless figure is the apparent spirit of a murdered and decapitated woman said to have been thrown on a landing stage, used for coal, within the tunnel known as Gilbert's Hole more than a century earlier. The tunnel's underground inhabitant is referred to most often as Kit Crewbucket. Interestingly, the specialist divers found the drowned man within hours, but did not report any sign of the resident Kit Crewbucket.

Although wider than the Brindley tunnel, it still only permits the passage of a single boat at a time and a system of signals and barriers prevent entry while traffic is in the tunnel travelling in the opposite direction. In 1990 a line of boats waiting to enter were given the clear signal by the tunnel keeper but then held back by the last boat to emerge, the man at the tiller saying there was a light behind him. They waited but, when nothing emerged, the first boat entered the tunnel only to reverse out rapidly when seeing the light heading towards him. Once more they waited and nothing emerged and so, when given the clear signal a second time, entered the tunnel once more. This time he reversed at the sight of the light but had not pulled clear when the barrier descended on the boat, smashing a

One end of the Harecastle Tunnel, which is still open.

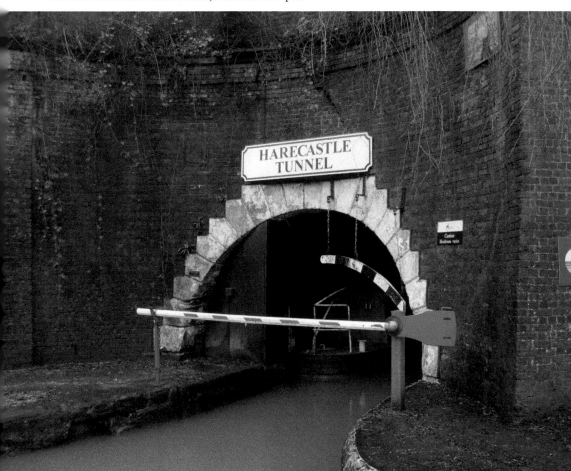

glass window and refusing to budge even when man-handled by six well-muscled men. Just as the line of boats had decided to call it a day the barrier inexplicably lifted slowly and silently, the line of boats passed through as the occupants kept a wary eye on the barrier and a look-out for lights.

The third, fourth and fifth tunnels were bored in 1848, by the North Staffordshire Railway between Tunstall and Kidsgrove. Predictably, if rather unimaginatively, known as the North, Middle and South Tunnels, these carried traffic for over a century until electrification of the line came in the 1960s. While Middle and South Tunnels were closed as unsuitable, North Tunnel was opened out but still proved unsuitable for electrification modifications. This produced the youngest of them all, the sixth tunnel constructed in 1965, carrying the now diverted line to the west and about 300 metres south of the station at Kidsgrove, before joining up with the original line again to the west of Tunstall. All three original railway tunnels total a length of 2 kilometres: North measuring 130 metres, Middle 165 metres, and South 1,615 metres – the latter today flooded for almost its entire length.

While we will often hear of the Harecastle Tunnel, invariably referring to Telford's canal tunnel as it is the only one accessible by the public, these six tunnels combine for a total length of 7.5 kilometres, which is longer than the Aintree Grand National race.

And alongside the now closed-off Harecastle Canal Tunnel.

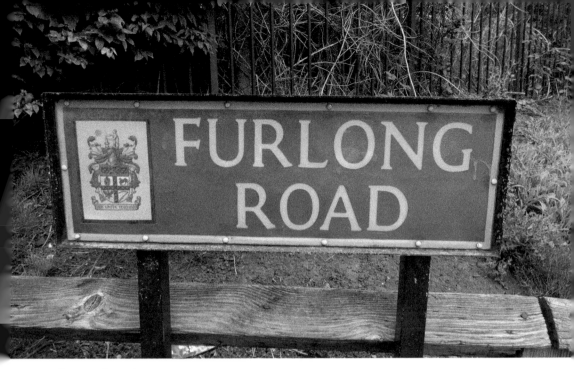

Above: Furlong sign.

Below: The tunnel's statistics and history marked by a blue plaque.

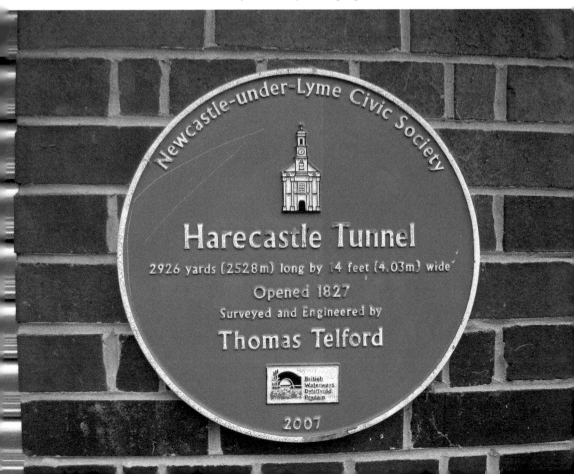

3

NORTH STAFFORD HOTEL

Probably the worst-kept secret in, or rather under, Stoke can be accessed via the North Stafford Hotel. This hotel is named after the North Stafford Railway, formed in 1845 to link the Potteries to neighbouring counties. It survived until 1923 when becoming part of the London, Midland & Scottish Railway and ultimately British Railways at nationalisation in 1948. Opening in 1849, the hotel served passengers using the Stoke railway station opposite. At this time, the company's boardroom was located on the top floor. The hotel and railway station are still connected.

The mosaic awaiting us at the southern end.

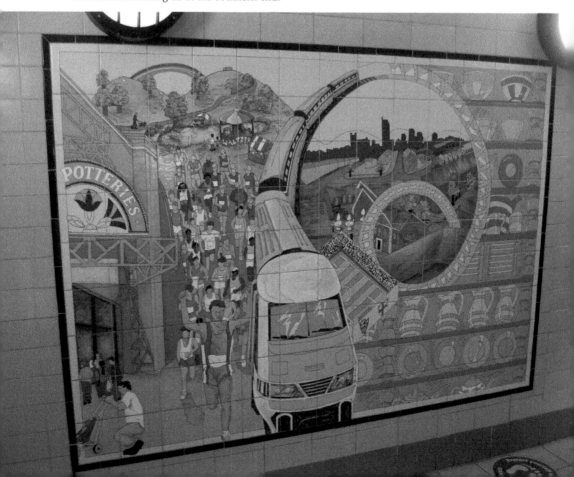

It is not clear when the tunnel appeared, for there is no record of construction between the opening until the 1880s and when the accounts show the purchase of tiling. It seems likely the tunnel was built nearer opening day, serving the board members arriving by train – assuming they were male. In the nineteenth century a stairway from platform one allowed male passengers only to descend and make their way to the hotel. Ladies would have to negotiate the busy street above, while keeping their long skirts clear of the inevitable mud and detritus found in these horse-drawn days.

This gender imbalance had nothing to do with discrimination, for no lady would have wanted to cross to the hotel through the tunnel as it led directly into the gent's toilet. The men could not simply answer a call of nature here, for behind the locked door at the hotel end is the original ticket collector's office, one hundred brass coat hooks, and oak benches. This seating permits travellers to await the services of the barber, offering a trim or shave after their journey.

Today the tunnel is no secret. Indeed, it is not unusual to find ladies requesting to see the marvellous tiling found here. Of course, today's visitors arrive via the stairs. Descending the staircase with its green and white tiles and ornate brass handrail, with four specially fired tiles telling us this is the 'LA-VA-TO-RY', every letter hand-formed with a glaze infill. On reaching the basement colours change, with subtle shades of green, peach and cream bordered by a ceiling of stylised blue tulips. As the accounts

The mosaic awaiting us at the northern end.

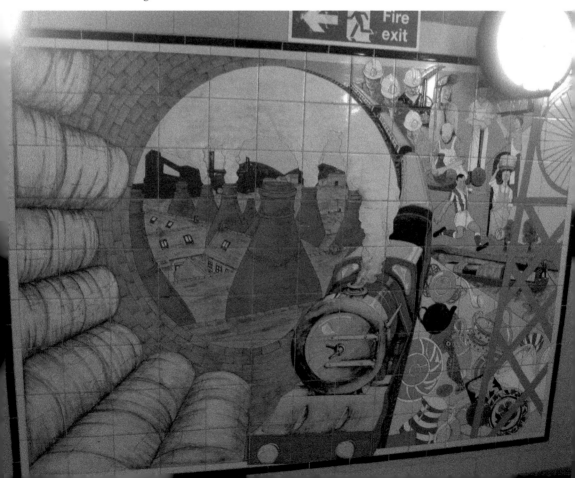

show, each tile pressed in a special mould using dust clay, all with rounded corners. The eye is drawn by lines to the friezes featuring contemporary scenes, including that of a kiln where these tiles, many unique, may well have been fired. Despite being 140 years old each tile looks in pristine condition and clearly none have ever required replacing.

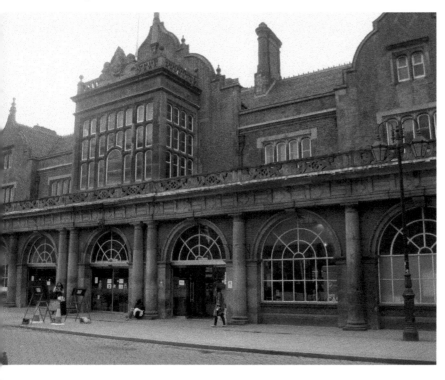

Left: Stoke-on-Trent railway station and opposite …

Below: … the North Stafford Hotel.

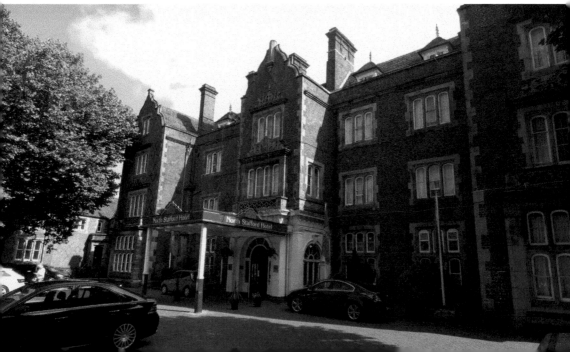

4

MEIR TUNNEL

In 1997 the motorists' nightmare of the A50 received what today might be called a makeover. It resulted in what we know as the Meir Tunnel. Meir is a region of the conurbation named for a former small lake or mere nearby, no sign of which is found today. Costing £18 million, part of a £125 million project to improve the A50, this improvement to the arterial road has split opinion as to whether the results are good or bad. Others maintain it has simply split the community.

Initially the idea to bring a dual carriageway into the Potteries would have used a flyover. While residents, traders and community representatives did not want to see houses cleared, it was the preferred solution. But a flyover would not only have blocked the view but also taken over a lot of land for the elevated sections require slip roads for traffic to access it. Success for the Meir Action Group led by chairman then Councillor Fred Ball, one of three groups protesting the plans, presented the alternative thirty-page plan. This succeeded and the result is what we see today.

The tunnel did not meet with everyone's approval. Hundreds of homes were cleared in the widening of the A50, all had to be rehoused. Yet most voices complained of this gash through the area splitting a community, including families and friends. A flyover may have been more invasive but it would mean the traffic problem went over Meir instead of through it. History shows the tunnel was the solution but still has its opponents. Leaving the dual carriageway takes motorists to a traffic island, a bottleneck somewhat assisted by traffic lights but still a problem.

Completed in 1998, the tunnel's first traffic came through on 28 November 1997. At 260 metres, it is not close to the longest tunnel in England but still ranks number fourteen, albeit very much shorter than the Queensway Tunnel under the Mersey at 3,237 metres. There is no doubting its attractive modern architectural design, each entrance emblazoned by the Stafford Knot picked out in the brickwork.

When constructed the Meir had a combination of fluorescent and low-pressure sodium lighting. However, this has been replaced by LED tunnel lighting, which adjusts to outside conditions, brightening and dimming as conditions change while not affecting drivers. Such reduces operating costs, carbon footprint and maintenance costs. Lower maintenance costs reveal less closure times and thus reducing potential dangers to the workforce.

In recent years drivers have noted signing stating the maximum height for vehicles as 16 feet 6 inches, but only when travelling westbound. We are promised the eastbound height is the same, although some sources suggest it comes out at 16 feet 9 inches, although this may be simply to explain why there is no sign as this is above the supposed minimum for signage.

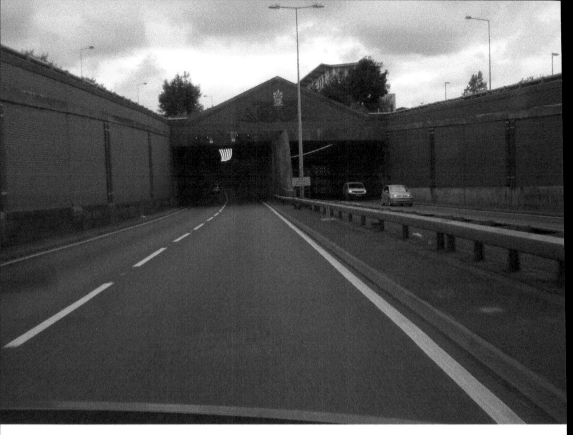

Above: Approaching Meir Tunnel.

Below: Inside Meir Tunnel.

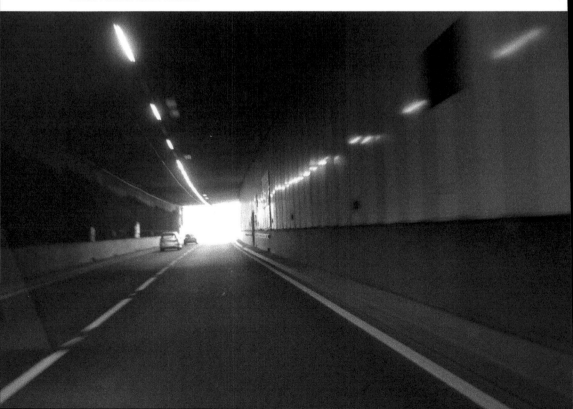

One further question to address: is this really a tunnel? Doubters point out it is simply an excavated dip in the road and subsequently covered. This process – officially known as cut and cover – is no longer used for the London Underground but, when the system was first constructed with steam power the lines had to be nearer the surface. However, the real reason for using cut and cover method in the capital was simply because it was cheaper. It seems impossible to think the London Underground at any time would not be said to run in tunnels.

As the book title indicates, for inclusion it should be underground. It is unlikely anyone will question those in other chapters. Yet undoubtedly some occupy sites once exposed at some time in the many millennia since the creation of our island. Land levels and features change constantly, and not always through man's direct influence. Soil erodes, rivers change course, and we landscape to build, for agriculture, for transport. As any archaeologist knows, earlier civilisations are found below the modern levels. Is there any argument as to whether they are underground today, or were once at ground level? Meir Tunnel is a tunnel by any definition, including that of every engineer.

The former Meir Station and its adjacent tunnel …

... although little of the railway can be seen today through the vegetation.

5

ROC POSTS

The Royal Observer Corps' posts were installed across the country as a warning system for UK defences and designed as part of the United Kingdom Warning and Monitoring Organisation. Initially manned first by British Army Personnel, then Special Constables, they operated during the First World War and, by 1936, were found across the land.

By 1957 the posts came under Home Office control. It is for their role in the event of a nuclear attack they are best remembered today. In the event of nuclear devices being detonated across Britain, the 1,563 underground monitoring posts, each approximately 8 miles from the next nearest, would provide vital information and data which, in association with the Meteorological Office, would produce data predicting where nuclear fallout should be expected.

Constructed from reinforced cast concrete and made waterproof, each was sunk to a depth of at least 25 feet. With the entrance shaft in place, the whole site was buried under a compacted soil mound, adding further depth and protection to the occupants. Descending the shaft via a metal ladder gives access to a single room, with only a separate compartment for the chemical toilet. Three occupied a cold, cramped and often damp compartment, kept alive by a store of food and water, electricity courtesy of a 12-volt lead-acid battery, recharged using a portable petrol electric generator. All 'furnishings' are fragments of past conflicts.

For the nuclear threat, new technologies and instrumentation detected the tell-tale pressures of a nuclear burst. Photography, when compared to those at other ROC posts, could accurately pinpoint location and size of the blast. Together this information would predict fallout. At £5,000 each this significant investment is indicative of the perceived danger. Now largely obsolete, many are long buried, possibly removed. But some remain, albeit in very poor condition, often on private land and with their access points the only indication anything exists below ground.

Within the area of the Potteries five ROC posts once existed. The entry point to that at Silverdale can still be seen not far north of the vast crater of the former Silverdale Colliery. Opening in 1962, volunteers maintained the post for three decades until officially closing in 1991. Located alongside the triangulation station or trig point, the remains are fast disappearing. Now badly burned inside, in 2006 a table, shelving, chairs, mattresses, papers and electrical equipment were still in situ. Today the post is open to the sky and the weather. Very unpleasant and most certainly climbing down to view is not recommended.

Another is found to the north of Pepper Street, Silverdale. What had proven of great service for many years, the post is now disused and quite inaccessible. This is nothing to do with the post, but as mentioned in an earlier chapter there is an underground fire nearby and nobody is quite sure how extensive the conflagration has spread. An on-going dispute between developers, protestors, and committees have closed off the area – albeit cattle and

sheep still graze here – until a decision can be made on whether this area is safe to build one hundred homes.

Two other posts in the area have vanished. Longton's post only opened in 1965 and closed three years later. Today the approximate centre of the Park Hall Country Park, accessed by Hulme Road, marks the approximate location. Here three paths converge near two field boundaries.

Above: Longton's ROC post off Hulme Road.

Below: The Park Hall Hills site today.

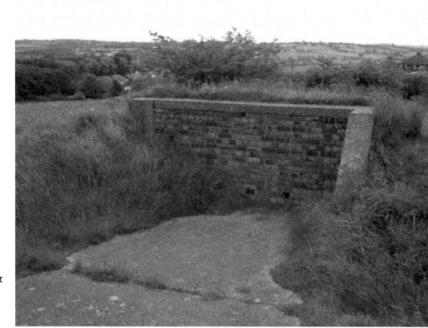

Right: Park Hall Hills from the other side.

Below: Hopper Fort car park, part of which is used as a track for models.

Meir Airfield Headquarters has not only disappeared by the area has been developed. The spot is easy to trace, directly opposite the junction of Falcon Road where it meets Lysander Road. The airfield was unpaved when opening in August 1920, but the surface made more stable for use during the Second World War. It closed following its last official flight on 16 August 1973, although there was another unofficial flight two years later by Eric Clutton in his Flying Runabout Experimental Design (or FRED).

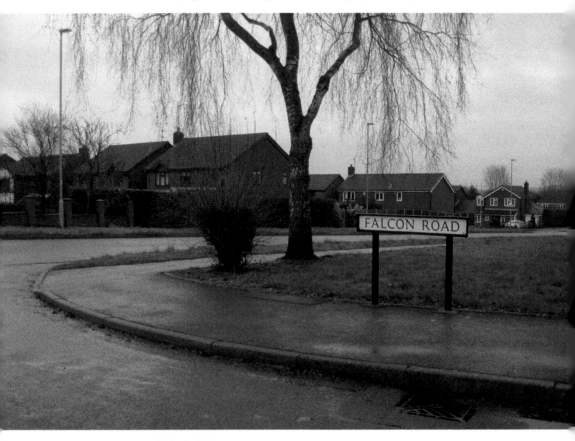

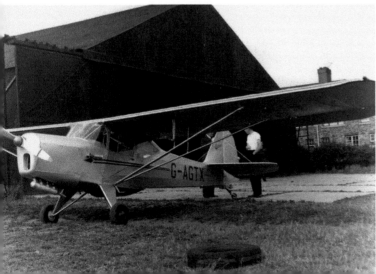

Above: No sign of the ROC post at Falcon Road today.

Left: Meir Airfield when in use. (Produced with kind permission of David Welch)

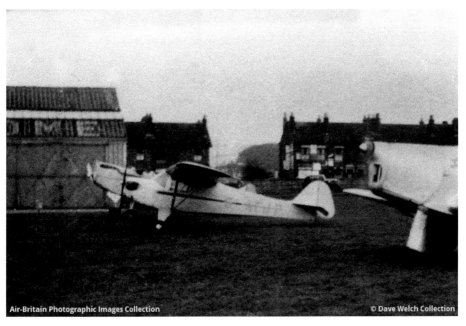

Air-Britain Photographic Images Collection © Dave Welch Collection

Another of Meir Airfield in former times. (Produced with kind permission of David Welch)

6

DRAYCOTT CROSS COLLIERY

As noted in our look at the former underground tunnel from Stoke station in Chapter 3, the North Staffordshire Railway served this part of the world. In 1848 the line from Uttoxeter opened, a branch to Cheadle soon proposed but failed several times until March 1887 and the formation of the Cheadle Railway, Mineral and Land Co. Ltd.

Branching off at Creswell, the line came through Totmonslow and on to Cheadle. Despite raising £100,000, the team of fifty men and horses engaged in construction meant the money soon ran out. Hence, the first quarter mile appeared in a month but the following mile, subsequent construction, and eventual opening took until November 1892. Not until January 1901, twenty-one days before the death of Queen Victoria, did the final section open to Cheadle and, eight years later still, took in the New Haden Colliery and now operating as North Staffordshire Railway.

To reach the colliery necessitated cutting a tunnel, a difficult engineering problem through a sandstone ridge. History shows difficulties in cutting the 895 metres were never really overcome. Several sections of brick lining and additional steel hoops patched the tunnel up until November 1918, when a significant collapse closed the line for a month. Although right at the end of the First World War, the importance of keeping the coal coming out meant the coal wagons were brought into the tunnel by one locomotive at the mine end, then pulled out the other using a second locomotive. Movement of wagons alone meant repair crews could continue to work on the tunnel from a timber platform, as trains passed below them.

Absorbed into the London, Midland & Scottish Railway in 1923, increasing problems saw a diversion planned in 1930, opening in 1933. This marked the end of the tunnel's use with the portals bricked up, the line to the south lifted, and the central section of the tunnel collapsing. The retained northern section could still be reached by reversing from Cheadle. Such problems for the line meant this has never been a part of British Rail's network, for when the railways (and ports and waterways) were nationalised on 1 January 1948, this section did not. As the London, Midland & Scottish Railway no longer existed from the last moment of 1947, it made this section of track effectively private.

This part of Cheadle Coalfield will have been mined using bell pits for hundreds of years. Deep mines were only sunk from the eighteenth century. Prior to that there is very little recorded, suggesting each working probably operated for only a few years at most. Two shafts were sunk at Draycott Colliery, though neither is thought to have produced much, hence records of closure are unavailable but will have been at some point during the 1940s. One shaft was capped using concrete, the other used by the Staffordshire Potteries Water Board.

Yet this did not stop coal coming from the southern portal. From 1983 to 1991 the privately owned drift mine of Draycott Cross Colliery produced small amounts. A narrow-gauge tramway was installed to move coal from just inside the existing southern portal. The wagons were tethered to a cable and moved using an external power source. Closure resulted in equipment becoming sealed underground, where it remains off limits to this day.

While it is not possible to view the tunnel interior today, images exist showing us just how littered and potentially dangerous the interior is. Where the roof has collapsed, the tunnel floor nearby is remarkably clear of obstructions. There is clear evidence the steel hoops are bending, with further roof collapses not just likely, but imminent. Note the floor has not suffered the build-up of dried mud found nearer the entrance where trains ran long after the collapse of the roof. Hence, we can deduce the collapse is not due to water or anything from outside. This is crumbling as it was not built to last.

Much of the litter near the entrance is hidden by the accumulation of dried mud. Yet most are still recognisable, possibly even usable, among the twisted metal, piping, plastic sheeting, upturned tubs, and rubble. A pile of concrete sleepers, each separated from its fellow by resting on broken bricks, while clearly suffering from the damp inside the tunnel, are at first glance in good enough condition to be used. In places the mud has been washed away by water seepage, this region being nearer the entrance, exposing the old rails enough to see how they separate towards the long-closed side entrance, evidenced by the larger breeze blocks used to construct. Further on remnants of the cable-hauled trucks on the narrow-gauge line can still be seen. By the gradient alone this clearly could never be hauled directly by a locomotive in the normal way.

Even from the outside it is clear the brickwork, clearly reminiscent of that used for more solid construction projects on Britain's railways, is in desperate need of repair if it is to remain open. Water damage is responsible, having eroded the mortar and created these holes, such can also be seen inside where minerals washed out by water seepage have stained and/or deposited traces on the tunnel walls. Today there is no access to any part of the tunnel, this land now held by a company who have fenced it off.

7

SILVERDALE COLLIERY TUNNELS

Another railway tunnel and another constructed by the North Staffordshire Railway. In 1846 this line came from north of Stoke through to Newcastle-under-Lyme, in part cleverly utilising the bed of Robert Heathcote's former canal. It incorporated a branch line running to Heathcote's ironworks at Silverdale, which was constructed by ironmaster Ralph Sneyd.

Known as the Silverdale and Newcastle-under-Lyme Railway, it was opened in 1850. Later it connected with other lines at Knutton Junction, then an extension linked these to the Newcastle Canal by 1854. This last half-mile section enabled the transport of coal, ironstone and iron, albeit initially using horse-drawn wagons.

ROC post off Pepper Street.

The almost perfectly straight Keele Tunnel is 294 metres long, while the Silverdale Tunnel, open by May 1863, extends just 62 metres. Built as a dual track, from October 1934 it was reduced to a single stretch. After nationalisation freight traffic increased significantly, peaking at half a million tons for the year of 1962 by which time the passenger traffic had ceased. The line ran until closure of the Silverdale Colliery in December 1998. The lines are rusting, the portals show signs of surface damage from water. Yet Keele Tunnel is not completely ignored for there are reports of wooden sleepers being stored here.

The last months of the Silverdale Tunnel were recorded before closure. Attempts to repair the brickwork inside is evidenced by seven ties and plates. These parts are dated 1996, hence clearly the work could not have been done prior to this and would have been finished before closure in 1998. There are also mineral stains on the tunnel walls, the result of decades of water seepage. Nothing of this can be seen today, although above ground the 3-metre diameter ventilation shaft still breaks the surface in a field south of Pepper Street. That area has been closed off to visitors for months, awaiting reports on a possible housing development.

8

CHATTERLEY WHITFIELD COLLIERY

In previous chapters we have seen examples of the coal industry's influence on the Potteries. Thus far we have only seen associated railway remnants under the Potteries. This comes as little surprise as the 100 square miles of the North Staffordshire Coalfield ceased all production in 1998. Chatterley Whitfield Colliery had been by far the most productive; indeed it was the first colliery in the United Kingdom to produce 1 million tons of saleable coal in a single year, achieved in 1937.

Chatterley Whitfield's remaining buildings.

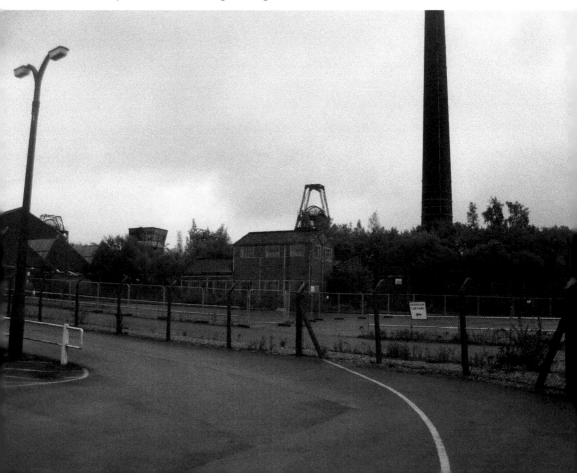

Early records of the mining here are sketchy but may show such beginning around the late thirteenth century. We are aware two to three hundredweights of coal carried by a team of six horses moved twice every day in 1750, for there is written evidence of complaints of roads quickly becoming impassable by waggons. By 1838 a detailed survey and accompanying valuation shows comparatively extensive mining already in situ, with an engine house, coal wharf, carpenter's shop and brickworks supporting a flourishing mining community.

Fifteen years later the shafts are descending 46 metres to the Bellringer and Ragman seams. Increased production more than warranted the extension of the lines of the North Staffordshire Railway to produce the Biddulph Valley branch line. However, their application in 1854 took another four years to become a reality and at first gave over at least as much capacity to mineral traffic until completed in 1860, after which coal quickly became the main cargo.

Yet it is not the working life of Chatterley Whitfield's colliery which is of interest, but what happened following its closure on Friday 25 March 1977. Over the next two years an independent trust worked to open this as Britain's first, and to date only, underground mining museum. They planned to allow visitors to experience the life of a miner while working below the surface. To achieve such necessitated renovation work on several now

Chatterley Whitfield's spoil heap has been nicely landscaped, although the black still shows through.

derelict buildings, underground galleries were made safe and machinery repaired and even restored to working condition.

In 1979 the museum opened its doors to the public and 70,000 visitors came annually. Those visitors descended 213 metres down the Winstanley shaft to enjoy this unique attraction. This was just the tip of the workings and not even close to the deepest part of the mine, for the Institute shaft reached down 402 metres and the Hesketh shaft 610 metres. Even more impressive the workings total some 50 miles of underground shafts and passages.

While the first visitors toured below, on the surface the mine's large spoil heap required attention. With official investigations and reports continuing to echo on some fifteen years after the Aberfan disaster on 21 October 1966, the closure of the workings gave an opportunity to reduce the conical spoil heap at Chatterley Whitfield. Beginning in 1976, the heap's height was eventually halved by completion of the landscaping project in 1982. Walking across this area today it is difficult to envisage how it would have looked.

During this time visitors would have been aware of nearby Wolstanton Colliery still producing coal. Wolstanton was much deeper at 914 metres and connected to Chatterley Whitfield in its latter years by a tunnel an impressive four miles long. When Wolstanton stopped production in 1981. Subsequent salvage work removed the machinery over several months and effectively marked the beginning of the end for the mining museum. Wolstanton is covered in more depth in chapter 14.

A winding wheel advertises Chatterley Whitfield's location.

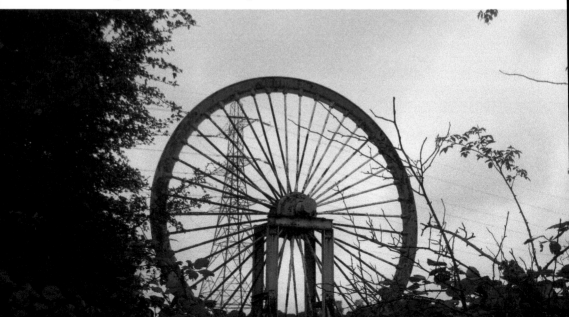

When operational the mines were under constant threat of flooding. Powerful steam-driven pumps worked every hour of the day to keep the mines clear of flooding. In the 1930s the North Staffordshire Coalfield was pumped clear of water by sixteen underground pumps. The sixteen pumps combined to pump an average 2.5 million litres of water every twenty-four hours. Emerging to form a pond at the surface, the water is then used in the boilers and washers. The irony here is the first steam engines were used to pump water out of coal mines – thus the mines produced both the coal and the water to power the pumps and enabled the mines to go much deeper.

With the removal of the last and deepest underground pump, water quickly flooded the lowest excavations, continuing to rise until it reached its natural underground level. The rising waters would not have affected the mining museum for several years but created a second problem. Methane, produced by decaying plant matter, which is compressed in producing coal, is released during mining and is highly explosive – miners referred to it as firedamp among other things – although fatalities are more likely to come from asphyxiation. Ventilation fans are installed in mines to clear the methane and provide fresh air. Rising water levels not only pushed up the methane from lower levels, but it is lighter than air and thus accumulates in the highest parts of the tunnels. Monitoring methane levels revealed not only should the mining museum be abandoned, but the mine workings needed to be capped to prevent the accumulation of methane from exploding.

Yet the underground experience did not end there. On 20 August 1986, with the shafts now sealed, British Coal helped to set up a mine tour at the surface. By plugging two shafts below the surface, the museum could still allow visitors to experience descending in a miner's cage in one shaft and see a demonstration of coal winding in the second. The museum also created an underground experience at the surface by adapting shallow workings, a railway cutting, while also utilising the former pithead baths and canteen installed in 1937. This effectively recreated underground Potteries at the surface. Unfortunately, the new experience did not prove financially viable and it was closed on 9 August 1993, but not before the author visited and experienced an attraction that eventually proved an inspiration for this book.

In 2019 the Victorian Society, and its president Griff Rhys-Jones, produced its twelfth annual report and earmarked Chatterley Whitfield as one of ten most endangered structures nationally. It does seem unlikely this will result in much interest in restoration; indeed lists from previous years appear to have had little influence on the sites named.

Yet the area is not completely ignored. Monitoring equipment reports on what is happening underground, keeping a wary eye – or more correctly an ear – on potential problems. Earth tremors are not uncommon, although these never make themselves detectable except by specialist equipment. Whether this will become a big enough problem to warrant action being taken, only time will tell.

9

BATHPOOL PARK

As we have already heard a railway tunnel runs beneath the northern region of Bathpool Park. For a park, this has a most unusual elongated shape. Aside from the usual children's playground area, cycle paths and grassy areas, here we find what is usually referred to as Bathpool Reservoir. Here up to 9.5 million litres of water are neither used as a canal feeder nor a domestic supply. As fishing is permitted it is officially categorised as an amenity and should be referred to as Bathpool Park Lake.

Bathpool Park hit the headlines on 7 March 1975, when the body of seventeen-year-old Lesley Whittle was discovered in a shaft. Kidnapped fifty-two days earlier, a ransom demand of £50,000 was made and Lesley's brother Ronald took the money to the rendezvous point. The shaft, marked by a torch, was to be the drop off point but Lesley's sibling lost his way and arrived late. When children found a torch wedged in the grille of the glory hole and another boy found a piece of Dynotape, they took the information to their headmaster and he alerted the police.

The grille topped the glory hole of a ventilation shaft of the old Harecastle Tunnel. Here the Dynotape machine and a notebook were discovered. A former inspection shaft was searched but nothing found. The third shaft, an air ventilation shaft for the former Nelson's Coal Mine, had to be checked for methane gas by HM Inspectorate of Mines before police could enter. Descending three ladders to landing stages, 39 metres down they found a body.

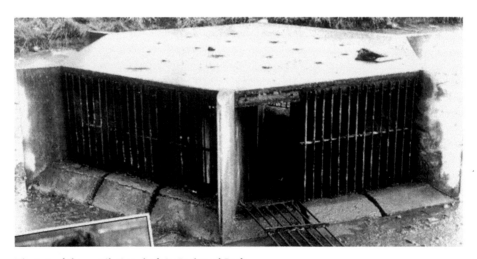

The top of the ventilation shaft in Bathpool Park.

Above: The now padlocked cover of the shaft where the body of the heiress was discovered.

Right: The shaft in which Lesley Whittle was found.

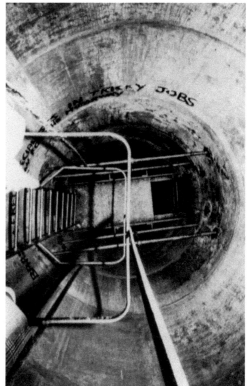

Naked, with a hood over her head and hawser around her neck tying her to the side, she had been provided with a mattress, blanket and rolled up sleeping bag on a ledge. It has always been thought she had been pushed by kidnapper Donald Neilson, aka the Black Panther. Under interrogation Neilson always maintained she fell, but there was no evidence to show whether he told the truth. It was certainly the noose which killed her and yet her fall had left her foot only 18 cm from the shaft's base.

The shaft, now fastened off with a very secure lock, stands near where the railway disappears beneath the ridge at this end of Bathpool Park. Now well wooded, albeit crossed by numerous impromptu paths through the trunks, the trees hide the ridge, which rises to a maximum of 23 metres above the track in the tunnel. Hence, with an estimated 8 metres between the top of the shaft and the summit of the ridge, Lesley Whittle spent the last days and hours of her life 25 metres below the level of the present-day railway track.

Neilson was arrested in July 1976, found guilty of this and three other murders and sentenced to life imprisonment. An appeal for his release on medical grounds in 2008 failed, and the man dubbed the Black Panther died a prisoner in December 2011.

Harecastle Tunnel from Bathpool Park, 1966. (Produced with kind permission of Martyn Pearson)

Above: A train enters Harecastle
Tunnel in a much more
overgrown Bathpool Park today.

Right: One entrance to Bathpool
Park.

10

POTTERY IN THE POTTERIES

While there are a few obvious locations for pottery in the Potteries being underground, the Potteries Museum and Art Gallery for example, we must remember why the industry grew here. Today the people of the area still remember when friends and family worked in mining to produce coal or quarrying to extract clay. Coal and clay are the basic requirements when producing pottery, although lead, salt, and water from the Trent helped, and this is the reason the industry came here and gave a name to the region.

For centuries pottery was made wherever it was needed. If in doubt look at the number of broken pots unearthed by archaeologists. There is even a name for broken pottery 'potsherds' and much of it will have been broken during production rather than transport or use. Although pottery has been produced here for 4,000 years, it was the small-scale industry in the seventeenth century that later flourished through the ideas and genius of the masters Wedgwood and Spode that made the region famous. With an established trade producing skilled workers, this, in turn, resulted in a quality product, and so the foundations of a traditional industry were laid.

Just as with local clays elsewhere, ivory clay and red or blue Etruria Marl gave the region's pottery a unique appearance. The six towns also benefitted from many individuals as a potential workforce. Unfortunately, sanitation was not what it is today, and disease soon proved a problem, not only because of the way we lived but the way we worked. Lead glazes used was the cause of the so-called 'Potter's Rot'.

At their peak at the turn of the nineteenth century, over 300 pot works required huge amounts of clay. Removal of such left rather more than scars in the landscape. How much of that remains to be seen today? Two sites belonged to Cobridge Brick & Marl Company: their main site alongside Leek Road and a second site at Scotia Road. The latter is now occupied by Tunstall Trading Park, although signs of the excavations can still be seen to the north of the football pitch, between Canal Lane and Harewood Street. Clay was transported out via the canal until it became cheaper by road.

While excavations are often seen as buried well below ground level, clay at Cobridge was only excavated to a maximum depth of 5 metres. A layer of yellow clay, averaging just 60 cm in depth, lay 2 metres below the surface, below which lay almost 2 metres of red marl.

Red marl clay was used for most early pottery and glazed with lead for a gloss finish, with iron or manganese for colour. White clays, of which there is much less, provided decoration or a coating. Yet clays were not only used for making pottery but also for lining ovens. Known as fireclays, they enabled the potters to fire the kiln to much greater temperatures without endangering the brickwork of the kiln.

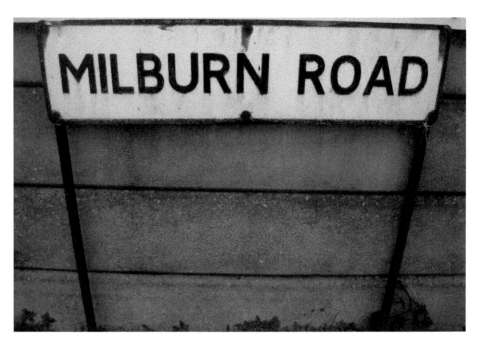

Above: Milburn Road
marks one of the access
points to the former
Cobridge Brick and Marl
site.

Right: This was Purbeck
Street, which also leads to
the old Cobridge Brick and
Marl site.

These clays were laid down in the Carboniferous, along with the coal, giving this geological period its name, between 300 and 360 million years ago. In the Potteries they exploited the Etruria and Ruabon marls. By the time of expansion in the eigheenth century clay had to be drawn in from places as far as Dorset and Devon. Bulk supplies of clay were brought in cheaply via the canal, particularly the Staffordshire and Worcestershire Canal from the River Severn, by the middle of that century. Ironically, considering the subject matter of this book, one of the first modern canals built for industrial purposes ran entirely underground in Cornwall, later used to convey ball and china clays to the ports and eventually to the Potteries.

The workings of Cobridge Brick and Marl are still where heavy machinery operates and there is strictly no entry.

11

ST JOHN'S CHURCH, BURSLEM

The churchyard of St John the Baptist's Church in Burslem has provided several stories over the years. One stands out above the rest, the tomb of Molly Leigh, for it is aligned north-south instead of the Christian east-west. Deemed a witch, she frightened both the rector and mourners at her funeral. There were reports of her familiar, a black bird, causing havoc everywhere the body was seen, and then she was seen walking around Burslem even after her burial. The rector is thought to have ordered the tomb to be realigned.

The author is indebted to Melanie Walley, who wrote regarding other tales told about this Burslem church, stories she has heard since a young girl. This church is not entirely the original building. Look closely and see how the main body of the church is brick-built, this dating from 1717 and replacing the earlier timber-framed construction after that had been destroyed by fire. The tower of St John's is stone, not brick, and dates from 1536, while the stone arch over the west door is also from the Tudor era.

Molly Leigh's burial is renowned for being turned through 90 degrees.

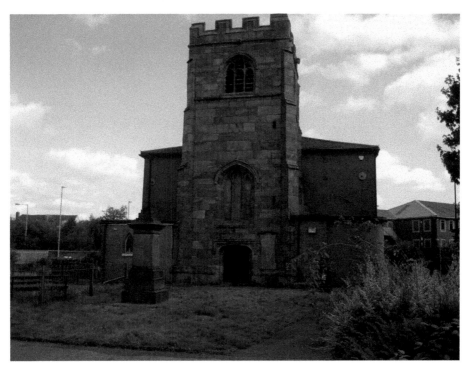

St John the Baptist Church, Burslem, where Molly Leigh is buried.

The surrounding churchyard was extended in 1804 and again in 1847. Between these dates two famous potters were interred here: William Adams (1746–1805), he and his family known for producing jasperware; and Enoch Wood (1759–1840), renowned for his figurines. Perhaps it is the association with these potters that spawned the oft-told belief that pottery of the most exquisite form is entombed with their greatest works in their graves in the churchyard.

But Melanie's more interesting memory is of the tunnels said to exist beneath the church. These would have dated from when the timber-framed church still stood here. Tradition has it that monks, presumably during the Dissolution of the Monasteries (1536–41), would remove valuables from the church to safety and out of the clutches of King Henry VIII as he broke away from the Catholic Church. The tunnel is said to have led to the cellar of the nearby Mitre Inn.

There is no evidence today to suggest any tunnels exist, be it from the church or the former public house – the Mitre being renovated in 2016 as the offices of Kelly Molyneux & Co. Ltd. This does not mean tunnels do not exist, simply they have never been discovered. Compared to other claims for long-lost underground passages, the length here does make it feasible. However, we must also point out the Mitre Inn has no record prior to 1912. Again, this does not mean there was no inn or building here before this.

Yet perhaps a positive clue is found in the name of the former inn. Any pub named the Mitre refers to the headdress worn by bishops and some abbots. But although worn by some Anglicans, it is rarely associated symbolically with anything but Catholicism. Whilst this could never be offered up as conclusive proof, it does offer some evidence of a perceived link between the building in Pitt Street and the nearby St John the Baptist Church.

Above: The former public house is now home to Kelly Molyneux at Burslem.

Right: The new occupants utilise the old pub sign to advertise.

12

ARCHAEOLOGY

This book is about accessible underground passageways, tunnels, shafts, cellars, crypts and caverns. Yet, as previously mentioned, there is a very grey area dividing the beneath from the buried. For example, when sealed at both ends to prevent access, a tunnel is no longer regarded as such and yet it remains a subterranean passageway. Similarly, a closed colliery with its seams mined-out and now great voids, capping for safety purposes may make these inaccessible but the workings are indisputably still in existence.

Maybe we should redefine the contents as man-made. But there are natural rivers and streams cutting through the rocks beneath virtually every settlement – these surfacing as spring water, that water source one of the reasons the site was selected for settlement in the first place – thus not all underground ways are man-made.

It seems whichever definition becomes the rule, such can only be regarded as a guide. While there is no intention to make this in any way an archaeological record, it is impossible not to acknowledge the many remains known to exist underground. Indeed, if just one of these unearthed sites proves of such importance as to merit leaving it in situ and the visitor centre eventually built over it, it could be that what is buried today may be regarded as underground in the future.

Astonishingly, at the time of writing, over 300 archaeological sites have been identified within a 6-mile radius of the geographical centre of the conurbation. These are classified as Mesolithic, Neolithic, Bronze Age, Iron Age, Roman, Saxon, Viking, medieval, post-medieval and, conversely, Unclassified Ancient and Unclassified Historic. In truth many of these 300 are sites where artefacts have been discovered, at least 20 per cent are industrial, mines for example, or unmovable, thinking particularly of the half-dozen sites with significant remains of Roman settlements.

13

HIDDEN WATERWAYS

Strictly speaking the following hidden waterways are all correctly either a river, stream or brook. While canals are man-made waterways, to refer to all the following as 'natural' would be incorrect for simply by covering, culverting and canalising these natural waterways we instantly make them man-made. Hence, these are referred to collectively as waterways.

As we deal with the canals quite separately, here we will concentrate on moving waters. There are a surprising number of known hidden waterways beneath the Potteries. Note 'known' as these only cover those rivers which come into the open at some point along their course. There are undoubtedly many springs and streams feeding these and other waterways, reservoirs, lakes or ponds which run wholly underground. Some underground springs and aquafers will be known and mapped, but not all.

It is not hard to see how the majority, indeed probably all, of the moving water in the Potteries eventually ends up in the river that has given the unitary authority its name. Statistics for the River Trent are impressive. It is the third longest river in the United Kingdom; runs through six counties, two cities and five towns (three of these incorporate the name of the river in the name of the place); it rises at 275 metres above sea level, flowing 298 kilometres to the sea; drains a basin of 10,435 square kilometres; and discharges an average 88 cubic metres of water every second into the Humber. It is well known for flooding, several settlements along its course having markers showing flood levels over the years, so perhaps it comes as no surprise to find its name refers to its tendency to flood for this is from a British term meaning 'trespasser'. What will be surprising is how, when it passes through the Potteries, one of the country's largest rivers vanishes from view.

Entering the city at Norton Green, the course soon becomes enclosed by development and concrete culverts. While not a great length of the river is hidden, that any can be found at all is astonishing. For many years the quality of the water through the city has improved, albeit slowly, but still requires much work to return it to anything close to its natural quality.

Ford Green Brook is named for where it enters the city at Brindley Ford. As it passes through the Whitfield Valley it collects impurities from sewage and run-off water from the former mines. Hence, by the time it joins the Trent at Milton it adds significantly to the pollution levels of its parent river. The same is true of Causley Brook, collecting mine water and rubbish between its source on Wetley Moor and joining the Trent at Ivy House.

One of the Potteries' rivers as it runs underground. As can be seen by the detritus washed downstream, this watercourse does run much deeper and more powerfully.

Scotia Brook begins at Turnhurst and run to the Fowlea Brook at Westport Lake. Fowlca Brook is officially discharging more pollution into the parent river than any other tributary. It joins the Trent at Stoke having only broken the surface at a few points as it journeys through Longport and Etruria. Lyme Brook, taking its name from the same forest as Newcastle-under-Lyme, is the town's main river. Forming part of the boundary, it joins the Trent at Hanford.

The River Blythe does not join the Trent until reaching Rugeley, but at Weston Coyney it forms the boundary, albeit for only 1 km. Lastly is a brook with several names. Beginning at Parkhall Lake, it is known as the Anchor Brook until it runs under Longton, where it has been recorded as the Longton Brook on some maps, until reaching Heron Cross. Now it passes under the former colliery at Hem Heath until joining the Trent at Trentham as Cockster Brook.

Above: Clayton Sports Ground's clubhouse.

Below: Clayton Sports Ground's scoreboard.

14

WOLSTANTON COLLIERY

Sunk in 1916, originally for iron ore as well as coal, not until the earliest years of the 1960s were the shafts developed extensively. By taking the shafts down to 1,156 metres below the surface, they made these the deepest mines in the country. Furthermore, the working face, taking the miners ever deeper, was deeper than anywhere in Western Europe.

Huge concrete towers at the surface housed three so-called 'Mine Winders', each driven by motors capable of producing 3,300 horsepower. This mine connected to neighbouring collieries underground: Sneyd, Whitfield, and Hanley Deep. When the mine closed in 1986, much of the equipment remained within the tunnels and seems will remain there for centuries. Eventually it will rust away, but not as rapidly as we would assume because the water which likely fills most of the workings today will protect the metal. Pure water will dissolve the metal much faster than it will ever rust. Indeed, iron needs oxygen and water to produce rust, thus if it is running water, which will likely introduce air into the system, rust will be the problem. We could not even guess at the amount of potential scrap metal and fresh water currently held underneath the site.

Wolstanton Retail Park.

Today Wolstanton Retail Park stands atop the old workings. The first shops opened three years after closure and a memorial plaque on the approach road remembers those who lost their lives over the years, with a winding wheel memorial also seen nearby. The new housing estate alongside is built on the former colliery's sports ground. Considerable opposition to the housing development focused on objections to increased traffic volumes rather than any nostalgia for the colliery or its sports club.

Right: A lasting reminder of the winding gear at the former coalfield at Wolstanton.

Below: A reminder of what existed at Wolstanton before the residential estate.

15

ETRURIA PARK

Laid out at the start of the twentieth century, the park opened in a typically grand ceremony on 29 September 1904, crowds coming in their thousands. These 11 acres, on land opposite the pottery works of Josiah Wedgwood and the Shelton Iron Works of Earl Granville, cost Hanley Corporation a purchase price of £4,719 17 shillings, and 6 pence. This amount, a substantial figure for the time, was paid out twelve years earlier.

Mr Robert Thompson FRHS designed the park, with lawns, flower beds, trees and shrubs and a carriage drive from the main gates. Two years later a fountain is erected, donated by the Shirley brothers of Etruria bone and flint mill. Today this forms a leisure area including an array of flower beds and lawns blend with leisure attractions.

Yet beneath the verdant surface lies a piece of history. Thanks to Peter Heath, who heard details from his mother, the author learned of a remnant from the Second World War still extant in the park. From the car park at Dundee Road, take the path towards the football pitches and note the sunken area. This marks the very spot where a former Second World War air-raid shelter lies buried.

This piece of history may not have survived had one Dr Stross, on behalf of Stoke-on-Trent City Council, had his way in February 1959. Doctor Sir Barnett Stross (1899–1967) represented first Hanley and latterly Stoke as MP from July 1945 to March 1966, during which time he served as Parliamentary Secretary to the Ministry of Health as part of the Labour government led by Harold Wilson in 1964/65. Dr Stross raised the question of this buried piece of history at no less a level than the Houses of Parliament.

Named after Thomas Curson Hansard, the London printer and publisher who was the first to officially publish same, Hansard is the traditional name given to the transcripts of parliamentary debates. Volume 599 of Hansard, on page 74, details a request by Dr Stross to remove the air-raid shelter in Etruria Park in the House of Commons on 12 February, a Thursday. The response came from the then Home Secretary, Mr R. A. Butler – better known as Rab Butler – who insisted he would not sanction their removal, not satisfied such an act would be justified.

As we have seen in the number of ROC Posts occupied well after Dr Stross' request, the threat of war never seemed far away in the 1950s. You can forgive Rab Butler for being cautious. This was but fourteen years after the end of the war and with little more than twenty years between the two great conflicts, nations were always looking over their metaphorical shoulders.

Above: Etruria Park still shows the rectangular outline of the former bomb shelter.

Right: The bomb shelter lies just behind and to the right of this sign.

16

MYATTS TUNNEL

David Muller came to the author's rescue in his search for further underground remnants. It is certain any examination of below ground will always produce much more from history than from the present. This does not reflect any destruction of urban architecture, something we often hear when bemoaning the loss of inner-city buildings, but it is simply a result of technological advances. What worked in the nineteenth and twentieth centuries rarely fits the bill in modern times.

One which does fit this description lies beneath Cobridge. What was the last piece of the Potteries Loop Line, Waterloo Road station opened on the April Fool's Day in the year of 1900. Costing a little over £3,000, it was the last to open on the line and sadly the first to close. Approached via cuttings 800 metres in length and up to 12 metres deep, the 300-metre tunnel is closed off but still exists beneath the now largely industrialised area. Getting on for 7,000 tons of earth had to be moved to excavate this part of the line.

Emerging from Myatt's Tunnel today will bring you to this vegetation and beyond to an industrial estate.

Yet there are much earlier excavations east and west of the former station site. These buried beneath the station's development site. Today there is no evidence of these former coal shafts and, aside from a single map, there is little evidence to show what form these workings took. Dates, depth, extent, tonnage, workforce, all are uncertain. Indeed, the only evidence of coal being mined is that single map.

Right: No longer used by the railway but clearly former railway property alongside the Trent and Mersey Canal.

Below: Old canal at Boothen Old Road.

17

SILVERDALE COLLIERY

Tunnels to the Silverdale Colliery are covered separately. Here we look at the colliery itself or, more accurately, what remains of the excavations. The colliery was the major employer here for more than a century, although always known locally as Kent's Lane.

With the first shafts were sunk in the 1830s, for the extraction of ironstone as well as coal, both items were almost solely for use by the Silverdale Forge. Using local supplies made far more sense at a time with much slower transport methods and thus more expensive per mile.

Little changed until the 1970s, when it was decided to completely rebuild the colliery to exploit lower levels of coal. Rather than upgrading existing equipment, the plan to start again proved a sound investment. Three new drifts were opened, increasing production to a level where more than a million tons of coal came to the surface every year. Eventually the mine closed in 1998, the last of the deep Staffordshire mines to close.

Yet the story continues. Two years before closure a spoil heap on Hollywood Road caught fire. It continues to burn underground to this day, although occasionally smoke and heat break through to the surface. When this happens the first signs are often seen when the trees of Holly Wood, which gives the road its name, seem to spontaneously combust.

A fire lasting two decades has been allowed to burn without any attempt to extinguish it. Experts are unsure just how extensive the underground fire has extended, there being no reason to believe this is but one fire but likely several smaller fires. If the fires have reached anywhere near the seams abandoned in 1998 as uneconomical to work further, any interference could result in these seams allowing the fire to spread and subsequently get out of hand. For the same reason there have been no attempts to develop the area for much-needed housing.

Above ground the Silverdale Country Park has provided 83 hectares where people can see nature restoring the balance after years of mining. Several pools, woodland, and purpose-built tracks offer a selection of walks of differing difficulties and lengths, with several starting points. There is a huge advantage if you can reach the highest point. Here, marked by Luke Perry's metal sculpture of the Guardian of Silverdale Colliery, is as good an overview of the former colliery as you will ever get while on *terra firma*. It is possible to see the topography of the site, a huge crater crossed by modern paths which is slowly returning to the verdant vista that existed before the first shaft was sunk.

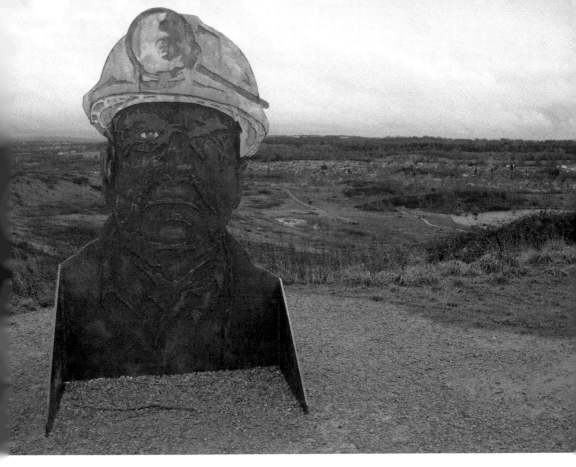

Above: Silverdale Country Park's guardian miner looks rather different on one side...

Right: ...than on the reverse.

18

SARAH SMITH OF WOLSTANTON

Whilst the author never intended to include anything in a book looking at what was underground unless it could be considered accessible in some respect, there is sometimes a fine dividing line between 'beneath' and 'buried'. For example, a former railway tunnel may not have been filled in, but when the ends have been sealed off and hidden under earth and/or concrete, the tunnel is as good as buried. Hence, I make no apologies for including a burial here.

Visitors to Wolstanton may be on a pilgrimage to see where engineer James Brindley breathed his last; or to find the home of Dr Henry Faulds, the pioneer of fingerprinting as a forensic tool; or that of former cricketer Harry Sharpe; maybe where professional footballer Dennis Higgins lived before he was killed in action during the Second World War; or even poet, teacher and playwright Arthur Berry, who died here in 1994. Yet many will have come specifically to St Margaret's Church to examine the grave of Sarah Smith.

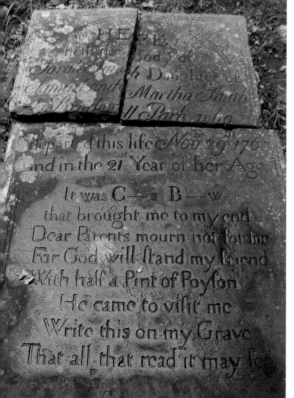

Sarah Smith's gravestone and its intriguing message.

Sarah Smith lived an unremarkable life, and little is known about her other than what appears on her headstone. When she died in 1783 someone commissioned the mason to produce a headstone that has intrigued for more than two centuries. On there is a short poem suggesting her death did not come naturally, for it reads: 'With half a pint of poyson he came to visit me, it was C....s B....w who brought me to me end.'

Clearly the message here is that she was poisoned, murdered by someone whose name is given only with the first and last letters of his two names. No census exists from the 1780s, and a search of the parish records from around this time offers no clues to who C....s B.....w may be. Of course, it is not Sarah who is the accuser but someone who survived to give the instructions and there may be not a grain of truth in the allegation. Yet if the accuser's intention had been to start rumours, they most certainly succeeded. Yet surely they could never have envisaged it would still be doing so almost 250 years after her death.

Wolstanton Church, last resting place of Sarah Smith.

19

HULTON ABBEY

As stated in the previous chapter, not everything underground is accessible. This poses problems when those remains have not been seen in living memory. The scheduled monument Hulton Abbey is one such example.

Founded by Henry de Audley in the early thirteenth century, our usual understanding of medieval religious houses is of a large and prosperous community. That may have been true of the parent house, the Cistercian Combermere Abbey in Cheshire, but records of this daughter house show it was quite small with barely adequate finances. Indeed, it had among the lowest income of all Staffordshire's religious houses. Initial growth, entirely down to the patronage of the Audley family, quickly levelled out. Sheep farming, a tannery and a fulling mill helped supplement their income, but a maximum annual income of £26 in 1291 hit an all-time low of £14 in 1354, the drop very much related to the bubonic plague. Dedicated to the Virgin Mary, they amassed little more than pennies from 1223 until dissolved by Henry VIII in 1538.

Little remains above ground today, the only evidence a few stones showing just a small part of the outline. That has not stopped archaeologists excavating to learn more. It appears this consisted of an abbey church, chapter house, dormitories and refectory around a square cloister. Yet lack of money does not mean this place lacks architectural interest. Remains do show this impoverished church and chapter house did feature some of the earliest known bar tracery windows in all of Britain.

The site quickly fell into disrepair and, by the nineteenth century, had been given over to agriculture. Not until 1884 did archaeologists rediscover it after investigative digs throughout the twentieth century and a major excavation between 1987 and 1994. Foundations are described as well preserved, while visible remains are weathering badly and the whole site in need of repair.

It is not clear just when the underground tunnels question arose. However, it is impossible for any talk to have been before the remains were rediscovered in 1884 – who could speak of passages serving a community which, as far as they were concerned, did not exist and never had. Yet it is often heard that the area around Hulton Abbey boasts any number of tunnels and passages heading in various directions. Some are said to have been for storage purposes – albeit normally referred to as cellars – although one is said to run to Stoke parish church.

If a passage exists from here to the church, it would require engineering expertise enabling it to pass beneath the River Trent and, even more unbelievably, extend at least 4 miles beneath the Potteries, while negotiating a significant descent and subsequent climb. It seems unfeasible that such an engineering project could have been undertaken by an

impoverished religious house, even if they had the technical knowledge. Even more relevant is water, which proved a problem for mining until the invention of the steam engine to pump water from the mines and would not have been an option for the residents (and supposed tunnel builders) of Hulton Abbey.

Hence it seems not just unlikely but impossible that such tunnels ever existed. Equally certain, we can be sure these stories will persist.

20

THE BASEMENT, HANLEY

In, or should that be under, Marsh Street, Hanley is one of the Potteries' premier nightspots. Appropriately named the Basement, since 2015 they have showcased a host of seasoned professionals playing music at high volume to a friendly and most enthusiastic audience.

From an architectural perspective it seems to be a bit of an understatement to call it a basement, which would suggest a compact, dark and dismal area. The Basement is far from any of those descriptions as any of the many late night (and early morning) visitors will attest. Rather than seeing it as 'a basement', it should always be 'The Basement', which reflects the large space given over to night life.

To find a centre for music under the ground is a reminder of times when interconnected basements under our towns and cities provided venues for live music. In the modern world, when any musical piece, and at any volume, can be demanded with but a sharp command to our virtual assistant, it is difficult to see a time when the only music at any volume available to most would have been played live. By playing in an enclosed area it accentuates the volume and helps contain the sound while not annoying the neighbours.

Without basement venues perhaps some of Britain's most influential and bestselling artiste's may have waited much longer to be discovered. In London the 2i's Coffee Bar was where Harry Greatorex discovered Cliff Richard, and Brian Epstein first saw the Beatles one lunchtime at the Cavern in Liverpool.

The Basement, where the action is below ground.

21

SACRED HEART CHURCH, TUNSTALL

Many churches have a crypt. Originally they were used to house coffins and sarcophagi of individuals from local families who sponsored their local church, thus earning the right to be interred there. Crypts once housed religious relics, although those were removed – destroyed, secreted or taken elsewhere – during King Henry VIII's Dissolution of the Monasteries.

Today crypts are given over to other uses. While most are, somewhat sadly, simply impromptu storage spaces, others have been given over to more creative uses. The author has visited crypts elsewhere and seen a visitor experience, a cafeteria and toilets. Tunstall's Sacred Heart Church falls under the 'creative' heading.

Sacred Heart Church at Tunstall.

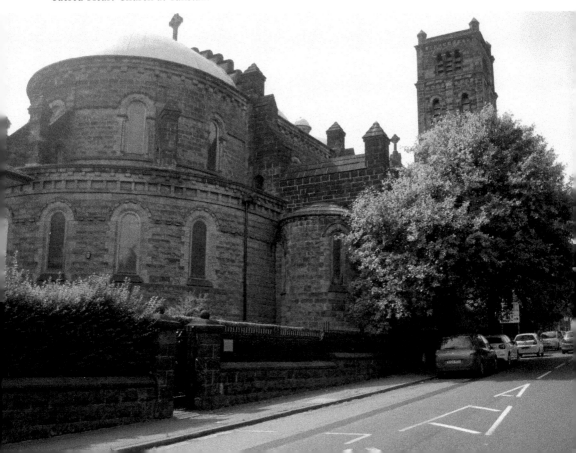

This church crypt, split to form several rooms for many years, had been used for storage, priest vestries and a small day chapel. In 2017, ambitious plans to transform this underground space were revealed. Organisers wanted to open this area up to produce a large space for local groups to meet, as a venue where conferences may be held, and as a base for local projects. Planners allocated £80,000 for the construction work, which commenced in late spring that year.

First the Sacristy was moved to ground level before planned partitions were installed along the walls and to the rear of the reredos. Next a new roof deck and cupboard space was put in; this ground level work completed the first phase. Successful grant applications led to phase two, which concentrated on that below the ground, following quite quickly. Clearing everything out enabled the basis for the community area to be installed, before a small kitchen area, toilets and audio-visual facilities completed the project.

The area is now open for use by local groups and available for bookings. The finished area is bright, clean and airy and belies the idea that anything underground is dark, dirty, damp and undesirable.

22

BERRYHILL FIELDS

Having already claimed this book will not include archaeological sites, here is Berryhill. However, in the author's defence this is not simply archaeology but also an excavation. As each have intertwined histories, it would be remiss not to mention both.

Geologists will describe the substrata of coal, sandstone, clay, and ironstone, all of which are of interest to the mining community. Historians will speak of an important manorial site and former deer park, while social, cultural, and even oral histories would undoubtedly place the emphasis on mining.

In 1998 the BBC and Keele University History Department descended on the site to investigate. A dovecote, clear evidence of an affluent community, pointed to a previously unrecorded site. They uncovered a comparatively sizable building, for the time, along with detached storerooms and farm buildings. Research suggested this was likely the manor of Fenton Vivian and Botteslow, a hunting lodge of the Standon family.

For over two centuries this will have been among the primary residences in the area. Evidence for the link to the Standons comes in the use of Vivian Standon's name for this part of Fenton,

Berryhill Fields welcomes us.

with Robert Standon recorded as landowner by 1293. With the family resident chiefly in Hertfordshire, using this as a hunting lodge, their influence in and around the Potteries waned with the arrival of the Black Death. Thereafter mining, and particularly for coal, took over.

Although mining likely began much earlier, it wasn't until the early nineteenth century that the substantial deposits were exploited on an industrial scale. We cannot be sure of any earlier mining activity. It is the steady growth from the early nineteenth century that suggests this developed over time rather than a sudden explosion of industry. The earliest map dates from 1790, but within twenty years much of this and the surrounding area would have been covered with mines.

By 1841, one W. T. Copeland of the Spode China works also held Berryhill. Although much of the workings closed inside thirty years, which was the result of amalgamations and takeovers, miners worked through until 1961 when, now under the auspices of the National Coal Board, 662 jobs were lost when the pit closed on 16 April, with some offered alternative employment. Yet, once again, this did not see the mine capped off and closed, for these workings were utilised as a centre for mine rescue training.

Mining is notorious for its dangers and many have lost their lives underneath Berryhill. In June 1949, a Mr Bott lost his life when buried alive by a fall of dirt. It took more than an hour to extract him, by which time he had died. A similar fate befell Samuel Johns and William Sherratt, but falling rocks and soil were not the only cause of fatalities. In October 1950, fireman Will Bromley died five weeks after being injured when using a compressed air hose, Robert Lawton died when struck by an iron support, Harry Pugh became entangled in machinery, and George Cordon was crushed by tubs coming up from the pit.

A reminder of what was once found here, the names of the seams are written on the rim of each wheel.

Just how Albert Humphries came to fall 900 feet down the shaft to his death in December 1952 was and remains a mystery. In April the following year, little sympathy came from the press when covering the inquest into the death of a miner, aged sixty, who died from injuries sustained when riding a tub underground, a practice strictly forbidden.

Coroner's courts seemed summarily unimpressed by foolish behaviour. In 1872 the jury and coroner spoke damningly of the 'foolhardiness of ignorant miners' who died following an explosion. After firing a shot to break the coal face, it seems an amount of gas had been released. Six miners died after inspecting the area with a lit candle. Rescue teams did reach them, but the miners died from resulting burns. There had recently been a warning, for only the previous year a gas explosion killed a man and a boy, and seriously injured three others.

Even before closure the announcement of moving the mining rescue team's training site to Berryhill had been made by the area manager of the National Coal Board, Mr Widdowson. Housed in the former pit head baths, it moved here from Glebe Street, Stoke, where it had been based for the last forty years. Opening in March 1962, up to fifty men were here at a time. This included those occupying the old fitters' shop now given over to training apprentices.

In the 1990s plans were made to reopen Berryhill as an opencast mine. Locals, many of whom had worked in, or who had family employed by, the Berryhill Field Colliery, vociferously opposed the plan. In July 1999 plans were officially dropped and opponents celebrated their victory.

Another underground fire problem, likely the same subterranean conflagration mentioned elsewhere (or an offshoot of same), has been burning for decades. In some reports £90,000 would solve the problem, in others figures as high as £700,000 have been quoted. Until the true extent of the fire is known, it seems the arguments and cost disagreements will continue.

Glebe Street, and it may look like a bridge and is even labelled a bridge but it is officially deemed a tunnel.

23

GLEBE PIT, FENTON

Glebe Pit, mentioned in the previous chapter as the former location for the mining rescue team's training site, had its own history. It seems only fitting we examine the remains of that pit still to be found beneath the Potteries in the twenty-first century.

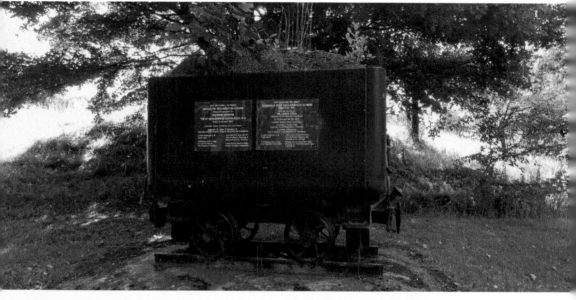

Glebe Pit, Fenton.

CITY OF STOKE-ON-TRENT
FENTON TIP, RECLAMATION SCHEME
Official Inauguration by
THE PRIME MINISTER
THE RT. HON. EDWARD HEATH, M.B.E., M.P.
Friday 1st October 1971.

Councillor Arthur Cholerton, J.P., Lord Mayor.

Alderman Sir Albert E. Bennett, J.P.
Chairman General Purposes (Sites & Industries) Sub-Committee.

L. Keith Robinson, LL.B. J. W. Plant, F.R.I.B.A., F.R.T.P.I.
Town Clerk.. City Architect, Planning &
 Reconstruction Officer
S. N. Mustow, B.Sc., C.Eng.,
F.I.C.E., F.I. Mun.E. P. Dyer, N.D.H., F. Inst. P.R.A. (Dip.)
City Engineer & Surveyor. Director of Parks & Cemeteries.

CITY OF STOKE-ON-TRENT
GLEBEDALE PARK RECLAMATION SCHEME
(FENTON TIP)
Official Opening by
MR. DEREK EZRA
Chairman of the National Coal Board
on Wednesday, 2nd May, 1973
Councillor William Austin, Lord Mayor
Councillor J. Monks-Neil
Chairman, Land Reclamation Committee
Councillor J. Westwood
Vice-Chairman, Land Reclamation Committee

L. Keith Robinson, LL.B. J. W. Plant, F.R.I.C.A., F.R.T.P.I.
Town Clerk City Architect, Planning and
 Reconstruction Officer
S. N. Mustow, B.Sc., C.Eng., P. Dyer, N.D.H., F. Inst. P.R.A. (Dip.)
City Engineer & Surveyor Director of Parks, Recreation and
 Cemeteries

Glebe Pit site.

Opening in 1865, when owned by John Challinor, it did not quite make a century of work, closing in October 1964. Around 450 were employed at the site, although transfers and offers from neighbouring collieries meant redundancies were unnecessary. Not until the summer of 1965 did work begin on clearing the pithead gear and plugging the pit shafts.

Some indication of the depth of the workings can be seen by a newspaper report from 1957. Cages used to access the mine plummeted to the bottom of the shaft. Dropping more than 700 metres to the bottom, the cages were unoccupied, and no injuries were reported, although the mine had to close for two weeks for repairs. Considering each face produced about 7 tons every day, this represented a significant loss of production.

Glebe Pit's history is littered with stories of accidents and incidents. Yet one report is quite unique. In 1890 Fenton's Christchurch Church had to be rebuilt owing to the major subsidence caused by the nearby Glebe Colliery. Ironically, the name of the Glebe Colliery comes from its association with the church, these the glebe lands of the parish church of St Peter ad Vincula.

Today the spoil heap is landscaped as Glebedale Park. The project was launched exactly seven years after closure by the then Prime Minister, the Rt Hon Edward Heath MBE, MP, along with several local dignitaries. A commemorative plaque and a mine tub to the south of the area act as a permanent reminder of the history of the area and the landscaping in the 1970s.

It is impossible to say how much free space there is underground today. Almost certainly one day the workings will throw up a problem through subsidence, flooding, and any number of factors. Every precaution has been made to ensure the workings are safe and there is no reason to believe those measures will not last for many years to come. Until that time, enjoy the landscaped area but keep in mind the mines beneath our feet.

24

APEDALE COLLIERY

Thus far the only way to access the voids below ground would be as a passenger on a train or a canal boat, except for a basement feature such as the nightclub of that name or the gents' toilets in the North Stafford Hotel. True, it is possible to walk through tunnels at Stoke station, and some stretches of canal tunnel are accessible on foot. But here, at the Apedale Heritage Centre, there is the chance to head underground at last.

Firstly, we should look at the working side of the colliery and something of its history. Records of mining during the Roman era have been found, and it is almost certain coal was extracted before the arrival of the Romans in AD 43. Archaeological evidence shows remains of a Roman fort at Chesterton covering 8 hectares, with a flourishing town at Holditch where residents were working with ironstone and coal by the second century AD. Some artefacts from this era are on display at the Apedale Heritage Centre.

Apedale Visitor Centre.

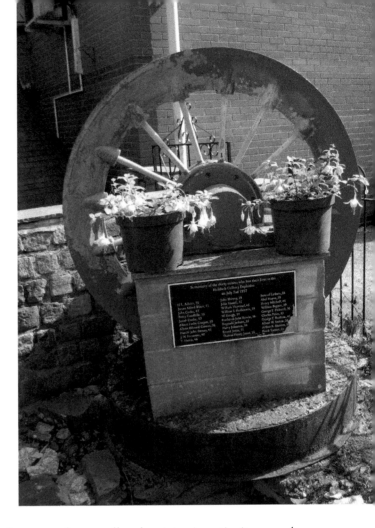

Apedale Visitor Centre
memorial.

As coal seams came quite close to surface, small scale mining in antiquity proved a comparatively simple task. Evidence of the shallow depth can be seen near the centre, the Great Row seam clearly visible on the cliff face.

Little change is seen for centuries. Small scale mining, usually a family operation, continued in a landscape almost entirely given over to agriculture. Not only coal, but iron ore is extracted, which is smelted locally. Together these resources provided supplies for blacksmiths, the potters, and domestic use.

For four centuries from the early seventeenth century, this land had been held by just three families. In 1620 Sir William Bowyer, later Lord Knypersely, took these lands. Eventually, through marriage to Dorothy Bowyer, they passed to Sir Tomas Gresley – they had two sons, Thomas and Nigel, the latter an ancestor of his more famous descendant, the locomotive engineer. Eventually, through marriage to Anne Gresley, the lands came to Sir John Edensor Heathcote.

The Heathcotes further developed the site, financed by the sale of the Apedale Canal. This waterway, opened in 1776, enabled boats to carry cargoes to the residents and factories of Newcastle-under-Lyme. Prices were strictly controlled to keep the costs affordable; for the first twenty years no more than five shillings (25 p) per ton and this only increased by ten per cent for the next two decades. Despite plans to the contrary, this canal never linked to any other but the Newcastle Junction Canal and, with competition from the railways,

closed in 1850. Little remains, although it is possible to discern the embankment across the Apedale Valley.

Not until the Industrial Revolution, with the resulting demand for coal, did the scale of mining begin to escalate. Deep mines were sunk from the late eighteenth century. Among the most productive were Wood Pit, Burley Pit, Watermills Colliery and Sladderhill Colliery. The latter is particularly interesting as the deepest in the country when, during the 1820s, the Heathcote owners sunk the shaft to 650 metres. Thereafter, workings extended laterally rather than vertically and all four pits were linked under Stanier & Co. near the end of the nineteenth century.

Today the Apedale Visitor Centre offers an insight into this history. The centre is a newish construction and, aside from that incorporated into its displays, little remains of the many buildings which had stood here over the years. Indeed, from the deep mine era, only the base of the 57-metre ventilation chimney of Watermills Colliery remains. Prior to the chimney's demolition, the Heathcote family requested the base be left to stand, one side panel bearing the inscription 'R.E.H 1840' – Richard Edensor Heathcote.

While the deep mines have little evidence above ground, the miles of tunnel beneath still exist. All are out of bounds today but, ironically, the original shallow workings are open to visitors. After the deep mines closed, the shallower mines were still worked by Aurora Mine Ltd. Seven drift mines operated during the 1980s. This ended in 1998, bringing an end to mining in Apedale after more than two millennia.

But the Aurora Mine is now a visitor attraction, courtesy of the Apedale Heritage Centre. Founded in 2001 and a part of the Apedale Community Country Park, the centre is staffed by volunteers, with funds coming from the café, donations, and mine tours. These tours not only allow a look at the surface features but also take in a drift mine, enabling visitors to the experience entitled 'Going Underground in the Potteries' first-hand. A light railway is an added attraction that shows the importance of railways in the area, while the centre also acknowledges the roles of the Apedale Ironworks and Apedale Brick and Tile Works. Unfortunately, there is nothing to see in the form of underground evidence of ironstone or clay extraction around Apedale.

25

KEMBALL COLLIERY

Above ground there is little evidence of the Kemball Colliery. Indeed, we are hard pressed even to find the road serving the colliery as it has been obliterated by the modern business park. Grove Road also allowed traffic to serve the Stafford Colliery and Hem Heath Colliery.

No sign of Stafford Colliery remains, although the site is unmistakeable. Where coal and iron ore were mined at the Stafford Colliery between 1873 and 1969 is now Stoke City's Britannia Football Stadium. How many of those in red and white scarves in the crowd on Saturday afternoon themselves were employed, or had friends and family who worked, underground in the Bowling Alley, Ten Feet, Winghay, Moss and Yard coal seams?

Stoke City's Britannia Stadium.

Holiday Express almost alongside the Britannia Stadium.

Under the control of the Stafford Colliery, Kemball was opened in 1876 and closed in 1963. During the war years the pit had been used to train new recruits. Known as Bevin Boys, they were conscripted to work the mines and increase coal production between December 1943 and March 1948. Named after Labour Party politician Ernest Bevin, they were chosen by drawing lots of male conscripts at the age of eighteen to twenty-five, 10 per cent of which went to work the mines (this included those who had volunteered). This amounted to just under 50,000 men. The conscripts worked the Pender and Bourne shafts. These later served as the return airway for nearby Hem Heath Colliery, which, until the 1950s, had only one shaft.

Hem Heath Colliery had its first ceremonial sod cut on 30 July 1924 by the Duke of Sutherland, the major shareholder, which is why this was known as the Duke's Pit. The resulting shaft soon ran into problems, when a fast-flowing underground stream threatened to halt work. This stream was also the reason a planned second shaft did not open until 1950, three years after the creation of the National Coal Board. Prior to this access came from Kemball Colliery.

Shafts at Kemball, now capped but still in existence underground, once allowed miners to descend via the cages to 560 metres on one side and to 970 metres on the other via the electric winders. Through the 1970s and 1980s a series of mergers and unifications, both physically underground and commercially above it, resulted in all the collieries here coming under the umbrella of the newly formed Trentham West & East. Yet with mining in decline the inevitable end came in 1993, British Coal officially deeming the mines as 'not required'.

As with other former mining sites, the tunnels and excavations have been made quite safe. Yet the underground stream found in 1924, or a connected watercourse, will inevitably remind us of the history of this site. This will not happen for centuries and we can only wonder what the future has in store for the site of the former Kemball Colliery and adjacent workings.

26

PARKHOUSE COLLIERY

Another former mineworking existed here from the nineteenth century. At first the extraction of ironstone from the Halfyards, Red Shagg, and Red Mine pits – which are 292, 310, and 330 metres deep respectively – were worked by Stanier until 1890, J. H. Pearson until 1905, and finally Robert Heath & Sons until 1929 when excavations ceased.

Yet the closure proved only temporary. In 1931, Mr James Scott employed 600 men to produce 180,000 tons per annum from the coal seam known as Great Row. Those three pits were now renamed, rather unimaginatively, Parkhouse 1, 2 and 3 and worked until closure came on 21 January 1968. To extract the coal required drilling down much deeper than for the ironstone galleries, reaching 600 metres below the surface.

As ever the shafts were capped but, as the term tells us, this only plugs the topmost area and the remainder, as far as we are aware, still honeycombs the Staffordshire landscape.

Refreshingly, the spoil heaps were not simply landscaped but utilised for other projects. Tarmac Construction purchased part of the extracted material for use on a road building scheme. The remainder of the site became a part of the reclamation scheme in the latter half of 1977.

27

ADDERLEY GREEN COLLIERY

Two shafts were sunk at Adderley Green. Known as number eight and number nine, they worked several seams between them. Coal, graded for quality for use by the household, in manufacturing and the best reserved for steam engines, came up from depths of 120 metres, in the case of number eight, and 195 metres, from the bottom of number nine.

In July 1860 five men died when the cage they were riding in hit an iron rail lodged in the wall of the shaft, the result of an accident the previous day. Pitched from the cage, they fell 25 metres to their deaths. Riding a cage at the beginning of a shift was quite against the

The site of Adderley Green Colliery.

rules, which stated an empty cage should be winched up and down to prove it was safe to ride before any workers were carried to the coal face. At the subsequent inquest the coroner judged no individual or body could be held responsible for the accident and yet stressed that colliery rules existed for a purpose and should be adhered to at all times.

Today the site is, as with so many former collieries, largely given over to an industrial estate. Beneath the surface several old shafts can be found. Most were described as 'old' (as in disused) when numbers eight and nine were operational. All the workings here were served by the Longton, Adderley and Bucknall Railway. While that line is not hidden underground, all traces have almost been eradicated on the surface. The view from above is the best view of the path running from Anchor Road and crossing the green belt between the industrial estate to the east and the housing estate to the west. This mirrors the line of the railway almost perfectly.

28

MOSSFIELD COLLIERY

Any history of Mossfield Colliery would be incomplete without reference to two explosions. This pit, sunk in the 1850s, boasted four shafts, albeit not all were open at the same time. Descending more than 450 metres in places, the Cockshead coal seam produced plenty of clean coal from a seam up to 3 metres thick.

In the nineteenth century clean coal would be highly prized and fetch the highest prices. As close to pure carbon as any coal is likely to be found, it produces more heat than more impure coals, leaves less residue, and produces less smoke. The latter is a problem today for it means it also releases more carbon dioxide into the atmosphere. In the nineteenth and early twentieth centuries, releasing vast amounts of a greenhouse gas would be unimportant (even unknown), whilst the lack of impurities produced far less visible pollution. Compare the clouds of dirty smoke belching from a steam railway locomotive a hundred years ago with that emerging from the funnel of the engine pulling at a heritage line today. By comparison, the modern engine is almost squeaky clean.

As already stated, two explosions dominate the history of Mossfield. The first in 1889 occurred while the colliery belonged to Hawsley and Bridgewood Limited. Two shafts, each a little more than 3 metres in diameter and only 15 metres apart, used separate cages operated by one engine – one ascending as the other descended. So-called gob fires,

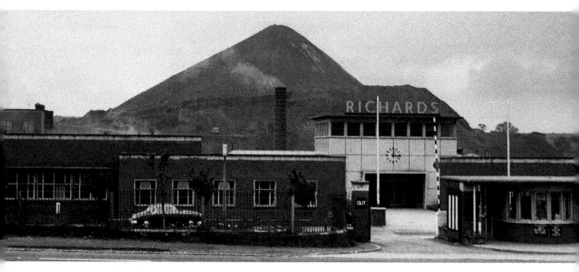

Mossfield Colliery.

spontaneous combustion of coal or wood used in constructions in the mines, were a constant danger at the time. A subsequent inquest pointed to gob fires as providing the ignition for the explosion in 1889, for witnesses reported detecting the odour synonymous with such shortly beforehand.

Seventy men were working in the mine when disaster struck at 3:50 a.m. on 16 October, sixty-four of whom were killed along with all sixteen horses. Numerous falls exposed other pockets of gas, making recovery work difficult. The energies released by the blast, and the lack of a warning, are revealed by one miner's body found near the coal face where he had been working. His clothes had been torn from his body and were found almost 8 metres away and, most tellingly, his belt torn off and a further 4 metres from the body, too.

Five of the bodies have never been found, despite three months of searching. Fireman Arthur Fletcher, aged twenty-six, and mine workers George Wilson, twenty-seven, Spencer Whitehurst, twenty-four, Joseph Bull, twenty-five, and William Bull, nineteen, all remain entombed somewhere beneath the surface.

With the Second World War just six months old, a second disastrous explosion occurred at 1:00 a.m. on 22 March 1940. Twelve men were working a new seam some 90 metres long, but less than a metre deep. Fifty years on and mechanical extraction process meant less men were required, so those working here that day numbered just eleven miners and a fireman. They had encountered troubles with faults on the narrow seam at around 30-metre intervals when the explosion came. All twelve men were found by rescuers, their bodies removed. Four were still alive, but only fireman Arthur Seaton (aged forty-seven) survived to speak at the inquest.

A nice reminder of what was once found near Mossfield...

Above: …on the new estate…

Below: …which many now call home.

In 1948 Mossfield regularly extracted record tonnages. The target of 7,800 tons was almost routinely exceeded, albeit not by much as the maximum was 8,393 tons. Two years later one of the disused shafts hit the news when the attempted rescue of a dog had to be abandoned owing to the dangerous condition of the old excavation. We must assume that dog's skeletal remains are still to be found there.

Once it was generally accepted that at least one son in the family would follow in his father's footsteps. This tradition resulted in a shocking story from January 1953. John Alcock, the foreman blacksmith on duty at the time, gave the signal for the cage he was working on to be lowered. He was unaware his twenty-eight-year-old son Kenneth had been underneath and killed instantly until raising the cage some hours later. His subsequent lifetime of anguish and distress is unimaginable.

Closing in 1963, the following decade saw the pit site and spoil heap landscaped as part of the Berryhill Fields reclamation project. In 1997 the Mossfield Corridor Project created a business park providing jobs for 1,000, roughly twice the number whose jobs ended with the closure of the pit, although most were able to take positions at neighbouring collieries.

PODMORE HALL COLLIERY

As already noted, Sir Nigel Bowyer Gresley brought the Apedale Canal through the Potteries. This enabled the first three major pits in this area - Wood Pit, Sladderhill and Podmore Hall – to transport their coal production to waiting markets.

A small village, Halmer End has a history dominated by coal mining. Served by the North Staffordshire Railway from its opening in June 1880, the line closed in 1963. Today the only evidence of the track bed is a footpath tracing out the route of this line from Audley to Alsager, the Railway public house and the name of Station Road.

Podmore is still remembered in road signs.

Little remains of the former colliery above ground. Yet there are some signs and most obviously is Bates Wood Lake, originally created by the run-off water associated with open cast mining. Then known as Cloggers Pool, this reservoir would be tapped to provide the water for the steam engine for the Minnie Pit. Thirty years after closure, work began on turning Cloggers Pool into Bates Wood Lake. Not until 2014, when the Audley Parish Angling Club took the helm, did the overgrown and heavily silted stretch of water start to become anything resembling the pristine fishing waters we see today.

Below the surface there is plenty of evidence of this former mining community. Minnie Pit reached down 350 metres to five thick and highly productive coal seams. Many will be aware of the Wilfrid Owen poem entitled 'Miners'. Published in 1918, it recalls events of 12 January 1918 at Minnie Pit when an explosion ripped through the mine.

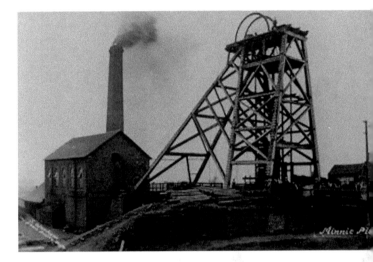

Right: Minnie Pit.

Below: Minnie Pit memorial

This had not been the first explosion here: gob fires were blamed for explosions in February 1898, when no lives were lost, and in January 1915, when nine died while working the Bullhurst Seam. When the 1918 explosion occurred, there were 248 out of a total of 405 employees working underground on the Four Feet, Five Feet, Banbury Seven Feet and Bullhurst Seams, all of which were interconnected. That part of the Banbury cuts was well protected, which shielded the mine from the effects of the explosion.

At the inquest, the coroner questioned whether adequate ventilation had been installed. Yet he could not see if the procedures had been followed by the overman, for his notebook with the gas readings had not been recovered and thus it would not be proper to apportion blame. Records were available to show all safety lamps had been checked and the men had been routinely searched for items not permitted underground. Despite the checks, however, the inquiry recorded the most likely cause had been a faulty lamp.

On that January day 156 men and boys died in the North Staffordshire Coalfield's worst ever disaster. Gas and visibility problems hampered the rescue. Indeed, it took eighteen months to recover every single body.

The mine never recovered from the disaster and closed in 1930. In recent years, a memorial to those who died here has been erected. A silhouette of a coal miner pushing a tub is seen, with the tub displaying the names of every one of the 156 who died here listed on the sides. That number is also found in the garden in which the memorial stands, for 156 rose bushes have been planted as a lasting reminder of those who died.

30

BIRCHENWOOD COLLIERY

Here is a colliery that closed in 1932. However, with most of the coal given over to coke and other by-products, processing of coal brought here from other collieries continued until May 1973. But that is jumping ahead and to envisage what lies beneath we need to return to the beginning of what had been by far the largest industrial estate in this area.

A coal deposit discovered by accident, found during excavation of the first Harecastle Tunnel, coupled with the iron ore deposits, brought about the iron and steel works, operating at the peak of production by 1871. This land, owned for centuries by the Colclough family, soon came under the control of Thomas Gilbert on behalf of the Duke of Bridgewater and the colliery began producing coal, which, at its peak, reached over 5,000 tons every week after opening in the 1890s.

No less than seventy-eight beehive ovens produced coke for the business owned by Robert Heath and later, on his death, his two sons.

In 1896, 124 new beehive ovens were built by the brothers. An indication of the success of the Heath family's business can be gauged by the investment of a staggering £1 million by the brothers over just a few years. Money spent, not just on ovens, but on a rail network, locomotives and housing for their employees. This made this area among the leading producers of coke in the country and a prosperous partnership developed.

When the brothers heard of the closure of the colliery mooted in 1925, they immediately purchased the mine. Within weeks the new company had been incorporated into their empire, but within three months an explosion ripped through their new investment.

On 18 December, an explosion killed seven men and injured fourteen others. Over the years thirteen different seams were worked, although by 1925 only three were still operational: Seven Feet Banbury, Eight Feet Banbury and Bullhurst. With a maximum excavation depth of 865 metres, travelling to the farthest extremity of the seam from the shaft saw a journey of 1,220 metres. Thus, a journey of more than a mile from where the workers entered the mine to where they could begin work.

As mentioned elsewhere, coal seams are subject to spontaneous heating. Indeed, records from Burchenwood show twenty areas where coal had once been extracted were now sealed off from the remainder of the mine because of the dangers of fire from such unpredictable heating. The Seven Feet, despite its name having a seam 10 feet in thickness, had a strong roof but a weak floor subject to movement. This released gas and resulted in the oxidation of the coal and subsequent rise in temperature. Thankfully, while accidents did happen, none of these problems had previously resulted in loss of life. Workers in December were not so lucky.

At 4:15 p.m. the explosion, the result of spontaneous combustion, created a fire which severely hampered any planned rescue procedure. Notes from that day showed no indication of heating or the so-called 'gob stink'. Survivors later reported a rush of air, evidence of a rock fall, before the alert of 'Fire!' went up. Four injured men were quickly removed, while fifteen in a lower level escaped injury and were brought to the surface.

Five other bodies, by necessity trapped behind the sealed-off section, could not be retrieved. Not until that area had been deemed safe enough to reopen could the brick and sand stop be removed and the five brought to the surface for burial. One was found on 18 March 1926, the remaining four thirteen days later.

Damage to the mine proved decisive. With output already severely hampered, the subsequent General Strike of 1926 added more pressure on the business and the owners. That year 84 of the coke-producing beehive ovens were closed. By 1928 a business employing 6,000, with sites across the county, is in administration. Final closure for the mine came in 1932, although, as already noted, coke production continued for more than forty years.

Today the area is Birchenwood Country Park. Paths, bridleways and cycle paths cross the 3-hectare site. Because of the industry once found here, the council ran extensive tests to ensure nothing toxic remains here, that testing continues regularly to ensure the safety of the users.

JAMAGE COLLIERY

Initially sunk as the Rookery Colliery as early as 1828, under the auspices of the Wedgwood Colliery Co., ten years later the site is bought by the Wood family and later, by 1950, the owners are given as Wood Price.

Some indication of the size of this colliery, and how accidents were almost accepted as inevitable owing to the nature of the work, one recorded comment speaks of the narrow access for Rookery only permitting small cages. It continues to state how the cages were so small it was impossible to allow the injured to lie flat when on a stretcher. The only way to get the stretcher (and its occupant) in the cage and to much-needed treatment was by angling the stretcher diagonally from corner to corner. It seems only the demands of the wars kept this shaft open until it closed in 1947.

One reminder of the colliery.

Above: Another reminder of the former Jamage Colliery.

Below: This is what occupies Jamage Colliery site today.

Jamage Colliery was opened in 1875. It was officially recognised as the first of the Bignall Hill Collieries. Another decade passed and thirty-six regenerative coke ovens were built here. 8 metres long, over 2 metres high and a little over 6 metres wide, each produced 3 tons of coke in forty-eight hours. Note, unlike the beehive ovens, which could be run purely by a day shift, regenerative coke ovens required round-the-clock tending by shift workers. This provided jobs for a comparable number above ground (119) as below (174).

At 250 metres, this has never been the deepest of mines and the lower seams always proved problematic. These problems are reflected in a cross-section of the workings where, instead of the usual regular and often symmetrical pattern, a loose collection of workings bear more resemblance to the excavations of a large burrowing animal. This haphazard layout would not have helped rescuers when an explosion occurred in November 1911.

The fire began at a depth of 320 metres, where five roads had allowed access, although two had been stopped because of the fire risk. There was still room for horses, coal tubs and workmen to pass, the three roads allowing for intake, haulage out and return.

Problems had been reported with a smell of gas for a couple of days. The explosion, which from the records had seemed inevitable, did not prove the killer in this instance. The six who lost their lives had been unable to escape when the explosion occurred and were found to have died as the result of carbon monoxide poisoning. These men, together

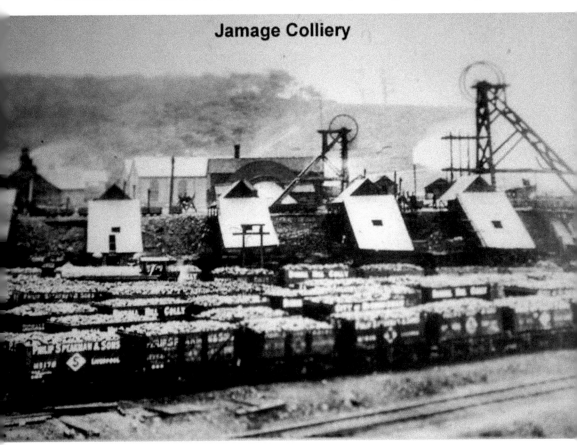

Jamage Colliery.

with twenty-seven ponies, were found dead when they were eventually found after rescuers managed to locate them after twenty-one days trapped underground. Astonishingly, several ponies were brought to the surface alive, albeit appearing rather emaciated after their three-week ordeal.

The colliery was closed in 1948 when ponies were still used to haul tubs underground. A large monument marks the site of the Wedgwood Colliery. Erected in 1850, storm damage in 1976 saw it reduced to only a quarter of its original size.

Memorial to the workers lost at Jamage.

32

OTHER COLLIERIES

A final look at the Potteries. Here we will look at some of the other pits, the remains of which honeycomb the ground beneath the region known as the Potteries. Approximately half of this book's subject matter looks at what remains underground looks at the former mine workings of the last two centuries and the author makes no apologies for such.

There are families who, within living memory, relied on the mines and quarries for their livelihood. Be it directly or indirectly, when excavation of the North Staffordshire coalfield, through various pits, reached a peak, nobody living and working in the Potteries could have avoided being affected by mining. This did not simply mean coal, for ironstone was also extracted and smelted using the coal. Although removal of the many different clays, particularly those used to make the items that gave the Potteries its name, involved quarrying more than mining, removing the clay has also left a substantial mark on the landscape.

This book has already looked in some detail at more than a dozen collieries, yet this is nowhere near a complete record. Indeed, it would be impossible to cover every excavation for many of those in antiquity have been lost. Undoubtedly the passages and shafts of these lost excavations still exist, but some have certainly been extended to such a degree as to have obliterated all signs of the earlier workings.

Other pits, listed below in alphabetical order, are not intended to be complete and should not be considered such. Here the intention is to acknowledge the existence of these underground tunnels, along with whatever has been left behind to give some clue to both the reason for their existence and to their age.

Bunkers Hill Colliery, Talke-on-the-Hill, had, by the late nineteenth century, become one of the leading employers in the village. Coal had been found here since the early sixteenth century, but it took a long time for technology to progress sufficiently to enable coal to be extracted on an industrial scale and permit the industrial community to grow. There are two disasters here: in 1866 when ninety-one men and boys were killed and another in 1875 that saw the deaths of forty-three more.

With the latter the explosion, caused by the spontaneous combustion of the dreaded firedamp, reports said the noise had been heard 4 miles away. When the bodies were removed from the mine and brought to 170 metres to the surface, nearly every villager turned out to watch. All these bodies were taken to the Swan Inn to be washed and prepared for funerals which many could never afford, for few had invested in the Widows'

and Orphans' Fund. The dead, the oldest forty-two and the youngest just thirteen, left no less than fifty-four children orphaned.

It is thought all the bodies were recovered, although some of the equipment will still be in situ.

Diglake, Dunkirk at Bignall End, had seen mining on an industrial scale since 1733. Three shafts sunk to 140 metres, 227 metres, and 240 metres and employed a good number of locals. On 13 December 1866 between 240 and 260 men and boys were working underground. One, fireman William Sproston, is thought to have fired a shot into a new seam to dislodge the coal when disaster struck. The blast weakened the barrier between this and old tunnels, long since abandoned and now flooded.

The breech allowed the water to come through at great pressure. Experts calculate the pressure of the incoming water as at least 100 psi (a fire hose works at 150 psi). Unlike most underground disasters it was the water, not fire or explosion, which proved fatal. At shortly before noon on 14 January the inrushing water saw seventy-seven workers in the shaft drown, including fireman William Sproston. Number of deaths has been cited as seventy-eight, this error coming from the memorial which has the same person listed twice, once with his name misspelled.

Today the workings are still underground and still flooded. Of the seventy-seven casualties only four were ever recovered, meaning the modern view hides the flooded passages, now a tomb for seventy-three bodies. In 2013 UK Coal's announcement

Leycett pit's memorial...

of opencast mining provoked a furious response from locals who feared the bodies would be uncovered. This was denied as the workings would never reach anywhere near such depths. The dispute proved irrelevant as the mining application failed to gain approval.

A memorial, featuring steel silhouettes of two miners kneeling, is in the churchyard of Audley Methodist Church, the same place the three bodies recovered were laid to rest in the nineteenth century.

Madeley Colliery, Leycett, opened in 1860, when known as the Fair Lady Pit, and worked until closure in September 1957. Unlike many pits, this mine closed over a significantly longer time scale than normal, which enabled machinery to be dismantled and taken for use elsewhere. In the earlier years no less than four accidents brought fatalities between 1871 and 1883.

In 1871 four died, eight years later five, and six in 1883. However, by far the biggest death toll came in 1880 when sixty-two men and boys were killed in an underground explosion. At 385 metres deep, seventy-seven were working below ground at the time. For 3 miles around the village residents heard the dreaded noise at 8.30 that Wednesday morning and immediately headed to the pit to hear news of husbands, father, brothers, or sons. In a mass funeral held on the following Sunday, all sixty-two were buried in the local churchyard.

...remembers the deaths of sixty-three miners.

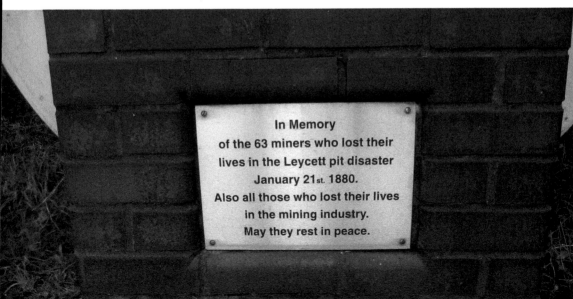

Ridgeway Colliery at Bemersley Green records its first collier in 1598. Yet monks are known to have removed coal prior to this, albeit never known as colliers. This historical link to Christianity continued through the years, with Bemersley known as the place where religious pamphlets and magazines – including the *Primitive Methodist* magazine – were printed. Ridgeway has records of having eight seams worked from outcroppings at the surface, the workings known as 'footrails'.

Bemersley Green looks a lot more rural today.

33

FINAL THOUGHTS

As we have seen in the preceding pages, there is no such thing as solid ground beneath our feet. Sewers, passages, tunnels, cables, pipes, excavations, underpasses, drains, mine workings, underground rivers, and much more produce a honeycomb underground.

Note this book has only looked at man's creations. If we add on all that animal life produces as these myriad creatures drive through the soil, the picture becomes even bigger. While a worm is not a large creature, there are a lot of them and as good soils have as many as a thousand worms per square metre, that amounts to a lot of worm-size tunnels. Moles, rabbits, badgers, rodents, and a myriad insect species burrow, too. It does make us wonder how much ground there is left to dig through.

Yes, these images become so mind-boggling they are difficult to visualise. Hence, let us look at our street. It does not matter which street, everywhere has a similar collection of tubes and wires beneath the pavements and roads. Take a short road, just thirty properties in length, cables for electricity, telephones and television (including internet), gas, fresh water, domestic wastewater, flushed waste from toilets, and drains from the gutter all means the first couple of metres under the street are nowhere near 100 per cent earth.

What is more that extends along the whole thirty properties. That is about 150 metres in length and remember we are only talking about one side of the street. And that applies no matter if we are looking at a row of tenement houses from the nineteenth century, or a lavish spread of multi-bedroomed detached properties with good-sized gardens. The size of the property is irrelevant; the pipes and cables still have to reach each property.

Next time you see the road dug up, maybe as you walk past, take a quick peep into the hole. You will probably get some odd looks, but you will not a care as you are fascinated by the complexity of something you walk over every day. It is no wonder the road is dug up for maintenance purposes and thank goodness that lot is not above ground, as there would be very little room left for us.

BIBLIOGRAPHY

Ballantyne, Hugh, *British Railways, Past & Present: North Staffordshire*
Lead, Peter, *Historic Waterways Scenes: The Trent and Mersey Canal*
Oppitz, Leslie, *Lost Railways of Staffordshire*